December twenty-forth 1918

To
My Beloved Lady Anne

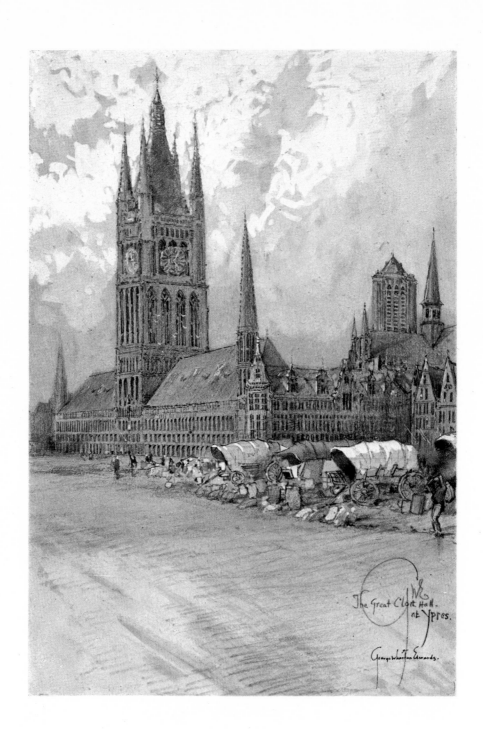

The Great Cloth Hall at Ypres.

George Wharton Edwards.

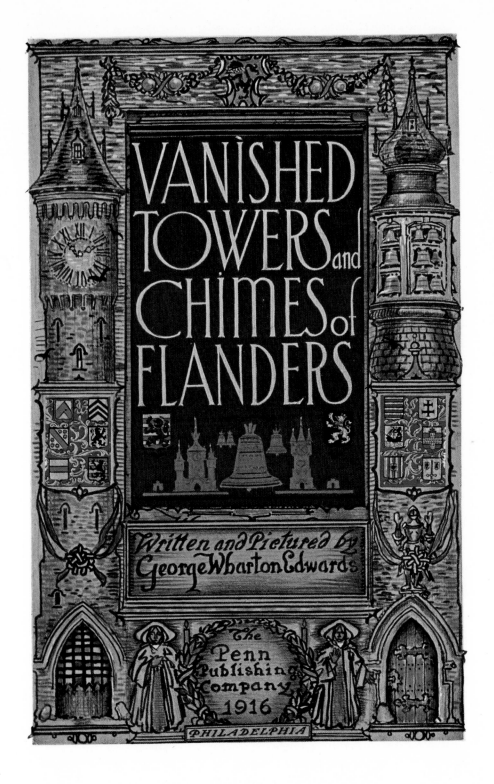

VANISHED TOWERS and CHIMES of FLANDERS

Written and Pictured by George Wharton Edwards

The Penn Publishing Company 1916

PHILADELPHIA

Vanished Towers and Chimes of Flanders

FOREWORD

THE unhappy Flemish people, who are at present much in the lime-light, because of the invasion and destruction of their once smiling and happy little country, were of a character but little known or understood by the great outside world. The very names of their cities and towns sounded strangely in foreign ears.

Towns named Ypres, Courtrai, Alost, Furnes, Tournai, were in the beginning of the invasion unpronounceable by most people, but little by little they have become familiar through newspaper reports of the barbarities said to have been practised upon the people by the invaders. Books giving the characteristics of these heroic people are eagerly sought. Unhappily these are few, and it would seem that these very inadequate and random notes of mine upon some phases of the lives of these people, particularly those related to architecture, and the music of their renowned chimes of bells, might be useful.

they were working for their own profit, were their own masters, and did not grumble. This grinding toil in the fields, as practised here where nothing was wasted, could not of course be a happy or healthful work, nor calculated to elevate the peasant in intelligence, so as a matter of fact the great body of the country people, who were the laborers, were steeped in an extraordinary state of ignorance.

If their education was neglected, they are still sound Catholics, and it may be that it was not thought to be in the interest of the authorities that they should be instructed in more worldly affairs. I am not prepared to argue this question. I only know that while stolid, and unemotional ordinarily, they are intensely patriotic. They became highly excited during the struggle some years ago to have their Flemish tongue preserved and taught in the schools, and I remember the crowds of people thronging the streets of Antwerp, Ghent and Bruges, with bands of music playing, and huge banners flying, bearing in large letters legends such as " Flanders for the Flemings." " Hail to the Flemish Lion " and " Flanders to the Death." All this was when the struggle between the two parties was going on.

The Flemings won, be it recorded.

Let alone, the Fleming would have worked out his own salvation in his own way. The country was prosperous.

FOREWORD

That the Fleming was not of an artistic nature I found during my residence in these towns of Flanders. The great towers and wondrous architectural marvels throughout this smiling green flat landscape appealed to him not at all. He was not interested in either art, music, or literature. He was of an intense practical nature. I am of course speaking of the ordinary or " Bourgeois " class now. Then, too, the class of great landed proprietors was numerically very small indeed, the land generally being parcelled or hired out in small squares or holdings by the peasants themselves. Occasionally the commune owned the land, and sublet portions to the farmers at prices controlled to some extent by the demand. Rarely was a " taking " (so-called) more than five acres or so in extent. Many of the old " Noblesse " are without landed estates, and this, I am informed, was because their lands were forfeited when the French Republic annexed Belgium, and were never restored to them. Thus the whole region of the Flemish littoral was given over to small holdings which were worked on shares by the peasants under general conditions which would be considered intolerable by the Anglo-Saxon. A common and rather depressing sight on the Belgian roads at dawn of day, were the long lines of trudging peasants, men, women and boys hurrying to the fields for the long weary hours of toil lasting often into the dark of night. But we were told

FOREWORD

The King and Queen were popular, indeed beloved; all
seemed to be going well with the people. Although Bel-
gium was not a military power such as its great neighbors
to the north, the east, and the south, its army played an
important part in the lives of the people, and the strate-
gical position which the country held filled in the map
the ever present question of " balance "; the never absent
possibility of the occasion arising when the army would
be called upon to defend the neutrality of the little coun-
try. But they never dreamed that it would come so soon.
. . . One might close with the words of the great Flemish
song of the poet Ledeganck:

> " Thou art no more,
> The towns of yore:
> The proud-necked, world-famed towns,
> The doughty lion's lair; "

(Written in 1846.)

[The Author]
Greenwich, Conn.
 April, 1916.

Contents

List of Illustrations

LIST OF ILLUSTRATIONS

Malines

VANISHED TOWERS and CHIMES OF FLANDERS

Malines

THE immense, flat-topped, gray Gothic spire which dominated the picturesque line of low, red-tiled roofs showing here and there above the clustering, dark-green masses of trees in level meadows, was that of St. Rombauld, designated by Vauban as "the Eighth Wonder of the World," constructed by Keldermans, of the celebrated family of architects. He it was who designed the Bishop's Palace, and the great town halls of Louvain, Oudenaarde, and Brussels, although some authorities allege that Gauthier Coolman designed the Cathedral. But without denying the power and artis-

17

try of this latter master, we may still believe in the well-established claim of Keldermans, who showed in this great tower the height of art culminating in exalted workmanship. Keldermans was selected by Marguerite and Philip of Savoie to build the "Greatest Church in Europe," and the plans, drawn with the pen on large sheets of parchment pasted together, which were preserved in the Brussels Museum up to the outbreak of the war, show what a wonder it was to have been. These plans show the spire complete, but the project was never realized.

Charles the Fifth, filled with admiration for this masterpiece, showered Keldermans with honors; made him director of construction of the towns of Antwerp, Brussels, and Malines, putting thus the seal of artistic perfection upon his dynasty.

Historical documents in the Brussels Library contained the following:

"The precise origin of the commencements of the Cathedral of Malines is unknown, as the ancient records were destroyed, together with the archives, during the troubles in the sixteenth century. The 'Nefs' and the transepts are the most ancient, their construction dating from the thirteenth century. It is conjectured that the first three erections of altars in the choir and the consecration of the monument took place in March, 1312. The

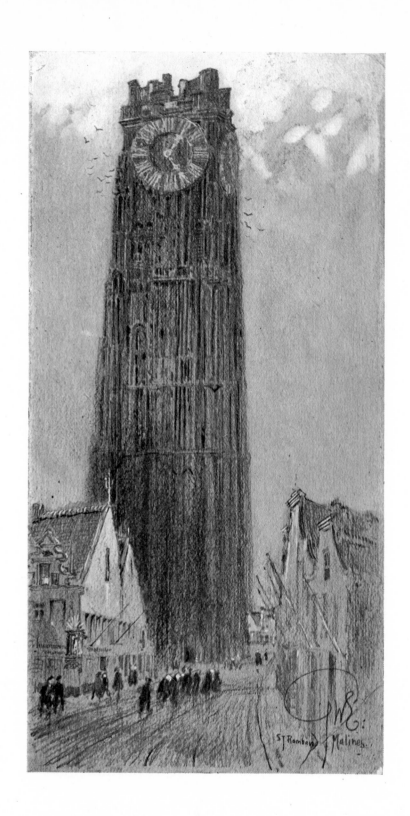

St Rambout, Malines.

great conflagration of May, 1342, which destroyed nearly all of the town, spared the church itself, but consumed the entire roof of heavy beams of Norway pine. The ruins remained thus for a long period because of lack of funds for restoration, and in the meantime services were celebrated in the church of St. Catherine. It was not until 1366 that the cathedral was sufficiently repaired to be used by the canons. Once begun, however, the repairs continued, although slowly. But the tower remained uncompleted as it was at the outbreak of the Great War, standing above the square at the great height of 97.70 metres." On each face of the tower was a large openwork clock face, or "cadran," of gilded copper. Each face was forty-seven feet in diameter. These clock faces were the work of Jacques Willmore, an Englishman by birth, but a habitant of Malines, and cost the town the sum of ten thousand francs ($2000). The citizens so appreciated his work that the council awarded him a pension of two hundred florins, "which he enjoyed for fourteen years."

St. Rombauld was famous for its chime of forty-five bells of remarkable silvery quality: masterpieces of Flemish bell founding. Malines was for many hundreds of years the headquarters of bell founding. Of the master bell founders, the most celebrated, according to the archives, was Jean Zeelstman, who practised his art for thirty

years. He made, in 1446, for the ancient church of Saint Michel at Louvain (destroyed by the Vandals in 1914) a large bell, bearing the inscription: "Michael prepositus paradisi quem nonoripicant angelorum civis fusa per Johann Zeelstman anno dmi, m. ccc. xlvi."

The family of Waghemans furnished a great number of bell founders of renown, who made many of the bells in the carillon of the cathedral of St. Rombauld; and there was lastly the Van den Gheyns (or Ghein), of which William of Bois-le-Duc became "Bourgeoisie" (Burgess) of Malines in 1506. His son Pierre succeeded to his business in 1533, and in turn left a son Pierre II, who carried on the great repute of his father. The tower of the Hospice of Notre Dame contained in 1914 a remarkable old bell of clear mellow tone — bearing the inscription: "Peeter Van den Ghein heeft mi Ghegotten in't jaer M.D. LXXX VIII." On the lower rim were the words: "Campana Sancti spiritus Divi Rumlodi." Pierre Van den Ghein II had but one son, Pierre III, who died without issue in 1618. William, however, left a second son, from whom descended the line of later bell founders, who made many of the bells of Malines. Of these Pierre IV, who associated himself with Pierre de Clerck (a cousin german), made the great "bourdon" called Salvator.

During the later years of the seventeenth century, the

Van den Gheyns seem to have quitted the town, seeking their fortunes elsewhere, for the foundry passed into other and less competent hands.

In Malines dwelt the Primate of Belgium, the now celebrated Cardinal Mercier, whose courageous attitude in the face of the invaders has aroused the admiration of the whole civilized world. Malines, although near Brussels, had, up to the outbreak of the war and its subsequent ruin, perhaps better preserved its characteristics than more remote towns of Flanders. The market place was surrounded by purely Flemish gabled houses of grayish stucco and stone, and these were most charmingly here and there reflected in the sluggish water of the rather evil-smelling river Dyle.

Catholicism was a most powerful factor here, and the struggle between Luther and Loyola, separating the ancient from the modern in Flemish architecture, was nowhere better exemplified than in Malines. It has been said that the modern Jesuitism succeeded to the ancient mysticism without displacing it, and the installation of the first in the very sanctuary of the latter has manifested itself in the ornamentation of the ecclesiastical edifices throughout Flanders, and indeed this fact is very evident to the travelers in this region. The people of Malines jealously retained the integrity of their ancient tongue, and many books in the language were published here.

Associations abounded in the town banded together for the preservation of Flemish as a language. On fête days these companies, headed by bands of music, paraded the streets, bearing large silken banners on which, with the Lion of Flanders, were inscriptions such as " Flanders for the Flemish," and " Hail to our Flemish Lion." On these occasions, too, the chimes in St. Rombauld were played by a celebrated bell-ringer, while the square below the tower was black with people listening breathlessly to the songs of their forefathers, often joining in the chorus, the sounds of the voices carrying a long distance. On the opposite side of the square, in the center of which was a fine statue of Margaret of Austria, adjoining the recently restored " Halles," a fine building in the purest Renaissance was being constructed, certainly a credit to the town, and an honor to its architect, attesting as it did the artistic sense and prosperity of the people. This, too, lies now in ashes — alas!

Flanders fairly bloomed, if I may use the expression, with exquisite architecture, and this garden spot, this cradle of art, as it has well been called, is levelled now in heaps of shapeless ruin.

Certainly in this damp, low-lying country the Gothic style flourished amazingly, and brought into existence talent which produced many cathedrals, town halls, and gateways, the like of which were not to be found else-

Malines: A Quaint Back Street

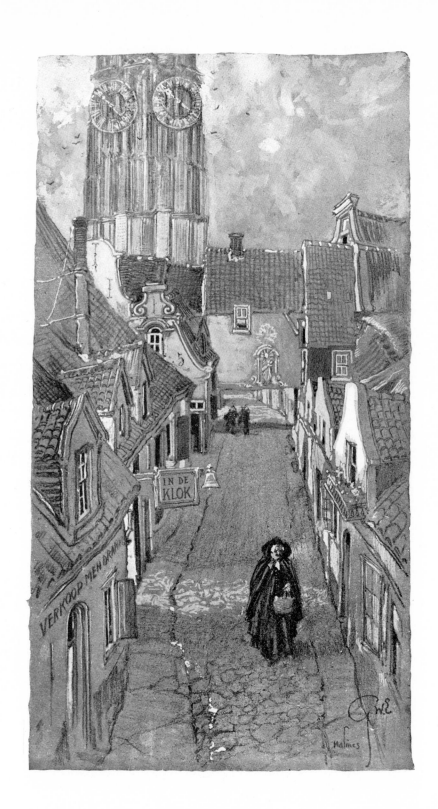

where in Europe. These buildings, ornamented with lace-like traceries and crowded with statuary, their interiors embellished with choir screens of marvelous detail wrought in stone, preserved to the world the art of a half-forgotten past, and these works of incomparable art were being cared for and restored by the State for the benefit of the whole world. Here, too, in Malines was a most quaint " Beguinage," or asylum, in an old quarter of the town, hidden away amid a network of narrow streets: a community of gentle-mannered, placid-faced women, who dwelt in a semi-religious retirement after the ancient rules laid down by Sainte Begga, in little, low, red-roofed houses ranged all about a grass-grown square. Here, after depositing a considerable sum of money, they were permitted to live in groups of three and four in each house, each coming and going as she pleased, without taking any formal vow. Their days were given up to church, hospital, parish duties and work among the sick and needy: an order, by the way, not found outside of Flanders.

Each day brought for them a monotonous existence, the same duties at the same hours, waking in a gentle quietude, rhythmed by the silvery notes of the convent bell recalling them to the duties of their pious lives, all oblivious of the great outside world. Each Beguinage door bore the name of some saint, and often in a moss-covered

niche in the old walls was seen a small statue of some saint, or holy personage, draped in vines.

The heavy, barred door was nail studded, and furnished usually with an iron-grilled wicket, where at the sound of the bell of the visitor a panel slid back and a white-coiffed face appeared. This secluded quarter was not exclusively inhabited by these gentle women, for there were other dwellings for those that loved the quiet solitude of this end of the town.

The Malines Beguinage was suppressed by the authorities in 1798, and it was not until 1804 that the order was permitted to resume operations under their former rights, nor were they allowed to resume their quaint costume until the year 1814.

In the small church on my last visit I saw the portrait of the Beguine Catherine Van Halter, the work of the painter I. Cossiers, and another picture by him representing the dead Christ on the knees of the Virgin surrounded by disciples. Cossiers seemed to revel in the ghastliness of the scene, but the workmanship was certainly of a very high order. The Beguine showed me with much pride their great treasure, a tiny, six-inch figure of the Crucifixion, carved from one piece of ivory by Jerome due Quesnoy. It was of very admirable workmanship, the face being remarkable in expression. Despatches (March, 1916) report this Beguinage entirely destroyed

by the siege guns. One wonders what was the fate of the saintly women.

On the Place de la Boucherie in Malines was the old " Palais," which was used as a museum and contained many ill-assorted objects of the greatest interest and value, such as medals, embroideries, weapons, and a fine collection of ancient miniatures on ivory. There was also a great iron "Armoire Aux Chartes," quite filled with priceless parchments, great vellum tomes, bound in brass; large waxen seals of dead and gone rulers and nobles; heavy volumes bound in leather, containing the archives. And also a most curious strong box bound in iron bands, nail studded, and with immense locks and keys, upon which reclined a strange, wooden figure with a grinning face, clad in the moth-eaten ancient dress of Malines, representing " Op Signorken " (the card states), but the attendant told me it was the " Vuyle Bridegroom," and related a story of it which cannot be set down here, Flemish ideas and speech being rather freer than ours. But the people, or rather the peasants, are devoted to him, and there were occasions when he was borne in triumph in processions when the town was " en fête."

The ancient palace of Margaret of York, wife of Charles the Bold, who after the tragic death of her consort retired to Malines, was in the Rue de l'Empereur.

It was used latterly as the hospital, and was utterly destroyed in the bombardment of 1914.

The only remnant of the ancient fortifications, I found on my last visit in 1910, was the fine gate, the " Porte de Bruxelles," with a small section of the walls, all reflected in an old moat now overgrown with moss and sedge grass. There were, too, quaint vistas of the old tower of Our Lady of Hanswyk and a number of arched bridges along the banks of the yellow Dyle, which flows sluggishly through the old town.

On the " Quai-au-sel," I saw in 1910, a number of ancient façades, most picturesque and quaintly pinnacled. There also a small botanical garden floriated most luxuriantly, and here again the Dyle reflected the mossy walls of ancient stone palaces, and there were rows of tall, wooden, carved posts standing in the stream, to which boats were moored as in Venice.

Throughout the town, up to the time of the bombardment, were many quaint market-places, all grass grown, wherein on market days were tall-wheeled, peasant carts, and lines of huge, hollow-backed, thick-legged, hairy horses, which were being offered for sale. And there were innumerable fountains and tall iron pumps of knights in armor; forgotten heroes of bygone ages, all of great artistic merit and value; and over all was the dominating tower of St. Rombauld, vast, gray, and myste-

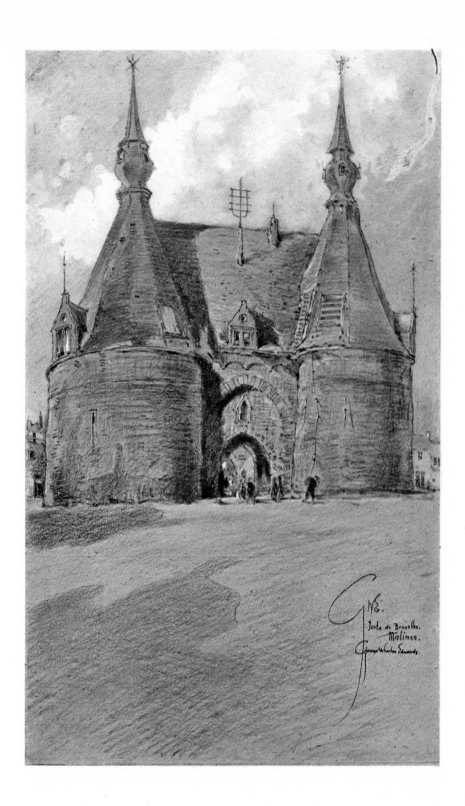

Porte de Bruxelles.
Malines.
George Wharton Edwards.

rious, limned against the pearly, luminous sky, the more impressive perhaps because of its unfinished state. And so, however interesting the other architectural attractions of Malines might be, and they were many, it was always to the great cathedral that one turned, for the townspeople were so proud of the great gray tower, venerated throughout the whole region, that they were insistent that we should explore it to the last detail. "The bells," they would exclaim, "the great bells of Saint Rombauld! You have not yet seen them?"

St. Rombauld simply compelled one's attention, and ended by laying so firm a hold upon the imagination that at no moment of the day or night was one wholly unconscious of its unique presence. By day and night its chimes floated through the air "like the music of fairy bells," weird and soft, noting the passing hours in this ancient Flemish town. For four hundred years it had watched over the varying fortunes of this region, gaining that precious quality which appealed to Ruskin, who said, "Its glory is in its age and in that deep sense of voicefulness, of stern watching, of mysterious sympathy, nay, even of approval or condemnation, which we feel in walls that have long been washed by the passing waves of humanity."

From below the eye was carried upward by range upon range of exquisite Gothic detail to the four great open-

27

work, gilded, clock discs, through which one could dimly see the beautiful, open-pointed lancets behind which on great beams hung the carillon bells, row upon row.

No words of mine can give any idea of the rich grayish brown of this old tower against the pale luminous sky, or the pathetic charm of its wild bell music, shattering down through the silent watches of the night, over the sleeping town, as I have heard it, standing by some silent, dark, palace-bordered canal, watching the tall tower melting into the immensity of the dusk, or by day in varying light and shade, in storm and sunshine, with wind-driven clouds chasing each other across the sky.

The ascent of the tower was a formidable task, and really it seemed as if it must have been far more than three hundred and fifty feet to the topmost gallery, when I essayed it on that stormy August day. It was not an easy task to gain admittance to the tower; on two former occasions, when I made the attempt, the *custode* was not to be found. "He had gone to market and taken the key to the tower door with him," said the withered old dame who at length understood my wish. On this day, however, she produced the key, a huge iron one, weighing, I should say, half a pound, from a nail behind the green door of the entry. She unlocked a heavy, white-washed door into a dusty, dim vestibule, and then proceeded to lock me in, pointing to another door at the farther end,

28

saying, as she returned to her savory stew pot on the iron stove, "Montez, Montez, vous trouverez l'escalier." The heavy door swung to by a weight on a cord, and I was at the bottom step of the winding stairway of the tower. For a few steps upward the way was in darkness, up the narrow stone steps, clinging to a waxy, slippery rope attached to the wall, which was grimy with dust, the steps sloping worn and uneven. Quaint, gloomy openings in the wall revealed themselves from time to time as I toiled upwards, openings into deep gulfs of mysterious gloom, spanned at times by huge oaken beams. Here and there at dim landings, lighted by narrow Gothic slits in the walls, were blackened, low doorways heavily bolted and studded with iron nails. The narrow slits of windows served only to let in dim, dusty beams of violet light. Through one dark slit in the wall I caught sight of the huge bulk of a bronze bell, green with the precious patina of age, and I fancied I heard footsteps on the stairway that wound its way above.

It was the watchman, a great hairy, oily Fleming, clad in a red sort of jersey, and blue patched trousers. On the back of his shock of pale, rope-colored hair sat jauntily a diminutive cap with a glazed peak. In the lobes of his huge ears were small gold rings.

I was glad to see him and to have his company in that place of cobwebs and dangling hand rope. I gave him

a thick black cigar which I had bought in the market-place that morning, and struck a match from which we both had a light. He expressed wonder at my matches, those paper cartons common in America, but which he had never before seen. I gave them to him, to his delight. He brought me upwards into a room crammed with strange machinery, all cranks and levers and wires and pulleys, and before us two great cylinders like unto a " Brobdingnagian " music box. He drew out a stool for me and courteously bade me be seated, speaking in French with a strong Flemish accent. He was, he said, a mechanic, whose duty it was to care for the bells and the machinery. He had an assistant who went on duty at six o'clock. He served watches of eight hours. There came a " whir " from a fan above, and a tinkle from a small bell somewhere near at hand. He said that the half hour would strike in three minutes. Had I ever been in a bell tower when the chimes played? Yes? Then M'sieur knew what to expect.

I took out my watch, and from the tail of my eye I fancied that I saw a gleam in his as he appraised the watch I held in my hand. He drew his bench nearer to me and held out his great hairy, oily paw, saying, " Let me see the pretty watch." " Not necessary," I replied, putting it back in my pocket and calmly eying him, although my heart began to beat fast. I was alone in the

tower with this hairy Cerberus, who, for all I knew, might be contemplating doing me mischief.

If I was in danger, as I might be, then I resolved to defend myself as well as I was able. I had an ammonia gun in my pocket which I carried to fend off ugly dogs by the roadside, which infest the country. And this I carried in my hip pocket. It resembled somewhat a forty-four caliber revolver. I put my hand behind me, drew it forth, eying him the while, and ostentatiously toyed with it before placing it in my blouse side pocket. It had, I thought, an instantaneous effect, for he drew back, opening his great mouth to say something, I know not what nor shall I ever know, for at that instant came a clang from the machinery, a warning whir of wheels, the rattle of chains, and one of the great barrels began to revolve slowly; up and down rattled the chains and levers, then, faint, sweet and far off, I heard a melodious jangle followed by the first notes of the " Mirleton " I had so often heard below in the town, but now subdued, etherealized, and softened like unto the dream music one fancies in the night. The watchman now grinned reassuringly at me, and, rising, beckoned me with his huge grimy hand to follow him. Grasping my good ammonia gun I followed him up a wooden stairway to a green baize covered door. This he opened to an inferno of crash and din. The air was alive with tumult and the booming of heavy metal.

VANISHED TOWERS OF FLANDERS

We were among the great bells of the bottom tier. Before us was the "bourdon," so called, weighing 2,200 pounds, the bronze monster upon which the bass note was sounded, and which sounded the hour over the level fields of Flanders. Dimly above I could see other bells of various size, hanging tier upon tier from great, red-painted, wooden beams clamped with iron bands.

I contrived to keep the watchman ever before me, not trusting him, although his frank smile somewhat disarmed my suspicion. It may be I did him an injustice, but I liked not the avaricious gleam in his little slits of eyes.

The bells clanged and clashed as they would break from their fastenings and drop upon us, and my brain reeled with the discord. On they beat and boomed, as if they would never stop. No melody was now apparent, though down below it had seemed as if their sweetness was all too brief. Up here in the tower they were not at all melodious; they were rough, discordant, and uneven, some sounding as though out of tune and cracked. All of the mystery and glamour of sweet tenderness, all their pathos and weirdness, had quite vanished, and here amid the smell of lubricating oil and the heavy, noisy grinding of the cog wheels, and the rattle of iron chains, all the poetry and elusiveness of the bells was certainly wanting.

All at once just before me a great hammer raised its

32

head, and then fell with a sounding clang upon the rim of a big bell; the half hour had struck. All about us the air resounded and vibrated with the mighty waves of sound. From the bells above finally came the hum of faint harmonics, and then followed silence like the stillness that ensues after a heavy clap of thunder.

Cerberus now beckoned me to accompany him amongst the bells, and showed me the machinery that sets this great marvel of sound in motion. He showed me the huge " tambour-carillon," with barrels all bestudded with little brass pegs which pull the wires connected with the great hammers, which in their turn strike the forty-six bells, that unrivaled chime known throughout Flanders as the master work of the Van den Gheyns of Louvain, who were, as already told, the greatest bell founders of the age.

The great hour bell weighing, as already noted, nearly a ton, required the united strength of eight men to ring him. Cerberus pointed out to me the narrow plank runway between the huge dusty beams, whereon these eight men stood to their task. The carillon tunes, he told me, were altered every year or so, and to do this required the entire changing of the small brass pegs in the cylinders, a most formidable task, I thought. He explained that the cutting of each hole costs sixty *centimes* (twelve cents) and that there were about 30,000 holes, so that the

change must be quite expensive, but I did not figure it out for myself.

The musical range of this carillon chime of Malines may be judged by the fact that it was possible to play, following on the hour, a selection from "Don Pasquale," and on the half and quarter hours a few bars from the "Pre aux Clercs." Every seven and a half minutes sounded a few jangling sweet notes, and thus the air over the old town of Malines and the small hamlets surrounding it both day and night was musical with the bells of the carillon.

On fête days a certain famous bell ringer was engaged by the authorities to play the bells from the *clavecin*. This is a sort of keyboard with pedals played by hand and foot, fashioned like a rude piano. The work is very hard, one would think, but I have heard some remarkable results from it. In former times the office of "carilloneur" was a most important position, and, as in the case of the Van den Gheyn family of Louvain, it was hereditary. The music played by these men, those "morceaux fugues," once the pride and pleasure of the Netherlands, is now the wonder and despair of the modern bell ringer, however skillful he may be.

Cerberus informed me that sometimes months pass without a visit from a stranger to his tower room, and that he

The Beguinage: Dixmude

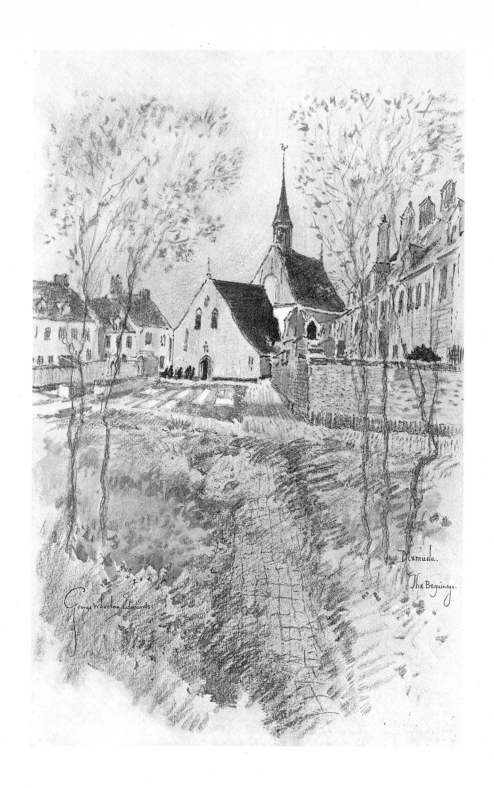

George Wharton Edwards

Dixmude.

The Beguinage.

had to wind up the mechanism of the immense clock twice each day, and that of the carillon separately three times each twenty-four hours, and that it was required of him that he should sound two strokes upon the " do " bell after each quarter, to show that he was " on the job," so to speak.

I told him I thought his task a hard and lonely one, and I offered him another of the black cigars, which he accepted with civility, but I kept my hand ostentatiously in my blouse pocket, where lay the ammonia gun, and he saw plainly that I did so. I am inclined now to think that my fears, as far as he was concerned, were groundless, but nevertheless they were very real that day in the old tower of Saint Rombauld.

He began his task of winding up the mechanism, while I mounted the steep steps leading upwards to the top gallery. Here on the open gallery I gazed north, east, south, and west over the placid, flat, green-embossed meadows threaded with silver, ribbon-like waterways, upon which floated red-sailed barges. Below, as in the bottom of a bowl, lay Malines, its small red-roofed houses stretching away in all directions to the remains of the ancient walls, topped here and there with a red-sailed windmill, in the midst of verdant fresh fields wooded here and there with clumps of willows, where the armies

of the counts of Flanders, and the Van Arteveldes, fought in the olden days.

I could see the square below where, in the Grand' Place, those doughty Knights of the Golden Fleece had gathered before the pilgrimage to the Holy Land. Now a few dwarfed, black figures of peasants crawled like insects across the wide emptiness of it. Here among the startled jackdaws I lounged smoking and ruminating upon the bells, oily Cerberus, and his lonely task, and inhaling the misty air from the winding canals in the fertile green fields below — appraising the values of the pale diaphanous sky of misty blue, harmonizing so exquisitely with the tender greens of the landscape which had charmed Cuyp and Memling, until the blue was suffused with molten gold, and over all the landscape spread a tender and lovely radiance, which in turn became changed to ruddy flames in the west, and then the radiance began to fade.

Then I bethought me that it was time I sought out the terrible Cerberus, the guardian of the tower, and induce him peaceably to permit me to go forth unharmed. I confess that I was coward enough to give him two francs as a fee instead of the single one which was his due, and then I stumbled down the long winding stairway, grasping the slippery hand rope timorously until I gained the street level, glad to be among fellow beings once more,

MALINES

but not sorry I had spent the afternoon among the bells
of the Carillon of Saint Rombauld — those bells which
now lie broken among the ashes of the tower in the Grand'
Place of the ruined town of Malines.

Some Carillons of Flanders

Some Carillons of Flanders

IT is worth noting that nearly all of the noble Flemish towers with their wealth of bells are almost within sight (and I had nearly written, sound) of each other. From the summit of the tower in Antwerp one could see dimly the cathedrals of Malines and Brussels, perhaps even those of Bruges and Ghent in clear weather. Haweis ("Music and Morals") says that "one hundred and twenty-six towers can be seen from the Antwerp Cathedral on a fair morning," and he was a most careful observer. "So these mighty spires, gray and changeless in the high air, seem to hold converse together over the heads of puny mortals, and their language is rolled from tower to tower by the music of the bells."

"Non sunt loquellae neque sermones, audiantur voces eorum," (there is neither speech nor language, but their voices are heard among men).

This is an inscription copied by Haweis in the tower at Antwerp, from a great bell signed, " F. Hemony Amstelodamia, 1658."

Speaking of the rich decorations which the Van den

41

Gheyns and Hemony lavished on their bells, he says, "The decorations worked in bas relief around some of the old bells are extremely beautiful, while the inscriptions are often highly suggestive, and even touching." These decorations are usually confined to the top and bottom rims of the bell, and are in low relief, so as to impede the vibration as little as possible. At Malines on a bell bearing date "1697, Antwerp" (now destroyed) there is an amazingly vigorous hunt through a forest with dogs and all kinds of animals. I did not see this bell when I was in the tower of St. Rombauld, as the light in the bell chamber was very dim. The inscription was carried right around the bell, and had all the grace and freedom of a spirited sketch.

On one of Hemony's bells dated 1674 and bearing the inscription, "Laudate Domini omnes Gentes," we noticed a long procession of cherub boys dancing and ringing flat hand bells such as are even now rung before the Host in street processions.

Some of the inscriptions are barely legible because of the peculiarity of the Gothic letters. Haweis mentions seeing the initials J. R. ("John Ruskin") in the deep sill of the staircase window; underneath a slight design of a rose window apparently sketched with the point of a compass. Ruskin loved the Malines Cathedral well, and made many sketches of detail while there. I looked

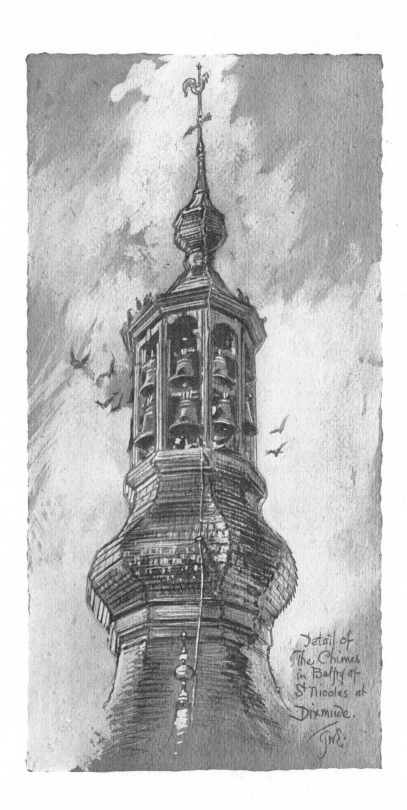

Detail of
The Chimes
in Belfry of
St Nicolas at
Dixmude.

TWE.

carefully for these initials, but I could not find them, I am sorry to say.

Bells have been strangely neglected by antiquaries and historians, and but few facts concerning them are to be found in the libraries. Haweis speaks of the difficulty he encountered in finding data about the chimes of the Low Countries, alleging that the published accounts and rumors about their size, weight, and age are seldom accurate or reliable. Even in the great libraries and archives of the Netherlands at Louvain, Bruges, or Brussels the librarians were unable to furnish him with accurate information.

He says: " The great folios of Louvain, Antwerp, and Mechlin (Malines) containing what is generally supposed to be an exhaustive transcript of all the monumental and funereal inscriptions in Belgium, will often bestow but a couple of dates and one inscription upon a richly decorated and inscribed carillon of thirty or forty bells. The reason of this is not far to seek. The fact is, it is no easy matter to get at the bells when once they are hung, and many an antiquarian who will haunt tombs and pore over illegible brasses with commendable patience will decline to risk his neck in the most interesting of belfries. The pursuit, too, is often a disappointing one. Perhaps it is possible to get half way around a bell and then be prevented by a thick beam, or the bell's own

wheel from seeing the outer half, which, by perverse chance, generally contains the date and the name of the founder.

" Perhaps the oldest bell is quite inaccessible, or, after a half hour's climbing amid the utmost dust and difficulty, we reach a perfectly blank or commonplace bell."

He gives the date of 1620, as that when the family of Van den Gheyns were bringing the art of bell founding to perfection in Louvain, and notes that the tower and bells of each fortified town were half civic property. Thus the curfew, the carolus, and the St. Mary bells in Antwerp Cathedral belong to the town.

" Let us," he says, " enter the town of Mechlin (Malines) in the year 1638. The old wooden bridge (over the river Dyle) has since been replaced by a stone one. To this day the elaborately carved façades of the old houses close on the water are of incomparable richness of design. The peculiar ascent of steps leading up to the angle of the roof, in a style borrowed from the Spaniards, is a style everywhere to be met with. The noblest of square florid Gothic towers, the tower of St. Rombauld (variously spelled St. Rombaud, St. Rombaut, or St. Rombod) finished up to three hundred and forty-eight feet, guides us to what is now called the Grand' Place, where in an obscure building are the workshops and furnaces adjoining the abode of Peter Van den

Gheyn, the most renowned bell founder of the seventeenth century, born in 1605. In company with his associate, Deklerk, arrangements are being made for the founding of a big bell.

" Before the cast was made there was no doubt great controversy between the mighty smiths, Deklerk and Van den Gheyn: plans had to be drawn out on parchment, measurements and calculations made, little proportions weighed by fine instinct, and the defects and merits of ever so many bells canvassed. The ordinary measurements, which now hold good for a large bell, are, roughly, one-fifteenth of the diameter in thickness, and twelve times the thickness in height. Describing the foundry buildings: The first is for the furnaces, containing the vast caldron for the fusing of the metal; in the second is a kind of shallow well, where the bell would have to be modeled in clay.

" The object to be first attained is a hollow mold of the exact size and shape of the intended bell, into which the liquid metal is poured through a tube from the furnace, and this mold is constructed in the following simple but ingenious manner:

" Suppose the bell to be six feet high, a brick column of about that height is built something in the shape of the outside of a bell. Upon the smooth surface of this solid bell-shaped mass can now be laid figures, decorations, and

inscriptions in wax; a large quantity of the most deli-
cately prepared clay is then produced, the model is
slightly washed with some kind of oil to prevent the fine
clay from sticking to it, and three or four coats of the fine
clay in an almost liquid state are daubed carefully all
over the model. Next, a coating of common clay is added
to strengthen the mold to the thickness of some inches.
And thus the model stands with its great bell-shaped cover
closely fitting over it.

" A fire is now lighted underneath, the brick work in the
interior is heated, through the clay, through the wax orna-
ments and oils, which steam out in vapor through two
holes at the top, leaving their impressions on the inside
of the cover (of clay).

" When everything is baked thoroughly hard, the cover
is raised bodily into the air by a rope, and held suspended
some feet exactly above the model. In the interior of the
cover thus raised will, of course, be found the exact im-
pression in hollow of the outside of the bell. The model
of clay and masonry is then broken up, and its place is
taken by another perfectly smooth model, only smaller —
exactly the size of the inside of the bell, in fact. On
this the great cover now descends, and is stopped in time
to leave a hollow space between the new model and itself.
This is effected simply by the bottom rim of the new

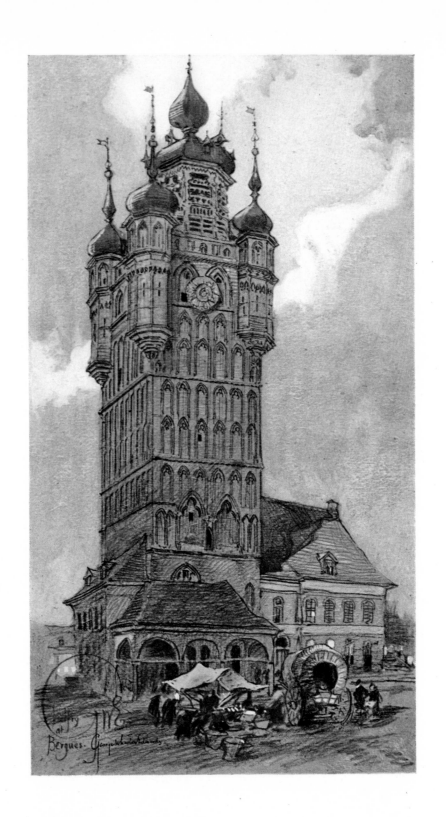

Bergues. Georges Schreiber

model forming a base, at the proper distance upon which the rim of the clay cover may rest in its descent.

" The hollow space between the clay cover and second clay mold is now the exact shape of the required bell, and only waits to be filled with metal.

" So far all has been comparatively easy; but the critical moment has now arrived. The furnaces have long been smoking; the brick work containing the caldron is almost glowing with red heat; a vast draft passage underneath the floor keeps the fire rapid; from time to time it leaps up with a hundred angry tongues, or in one sheet of flame, over the furnace-imbedded caldron. Then the cunning artificer brings forth his heaps of choice metal, large cakes of red coruscated copper from Drontheim, called " Rosette," owing to a certain rare pink bloom that seems to lie all over it like the purple on a plum; then a quantity of tin, so highly refined that it shines and glistens like pure silver; these are thrown into the caldron and melted down together. Kings and nobles have stood beside those famous caldrons, and looked with reverence upon the making of these old bells. Nay, they have brought gold and silver and, pronouncing the name of some holy saint or apostle which the bell was thereafter to bear, they have flung in precious metals, rings, bracelets, and even bullion.

"But for a moment or two before the pipe which is to convey the metal to the mold is opened, the smith stands and stirs the molten mass to see if all is melted. Then he casts in certain proportions of zinc and other metals which belong to the secrets of the trade; he knows how much depends upon these little refinements, which he has acquired by experience, and which perhaps he could not impart even if he would, so true is it that in every art that which constitutes success is a matter of instinct, and not of rule, or even science.

"He knows, too, that almost everything depends upon the moment chosen for flooding the mold. Standing in the intense heat, and calling loudly for a still more raging fire, he stirs the metal once more. At a given signal the pipe is opened, and with a long smothered rush the molten metal fills the mold to the brim. Nothing now remains but to let the metal cool, and then to break up the clay and brick work and extract the bell, which is then finished for better or for worse."

We learn much of the difficulties encountered even by these great masters in successfully casting the bells, and that even they were not exempt from failure. "The Great Salvator" bell at Malines, made by Peter Van den Gheyn, cracked eight years after it was hung in the tower (1696). It was recast by De Haze of Antwerp, and ex-

isted up to a few years ago — surely a good long life for any active bell.

In the belfry of St. Peter's at Louvain, which is now in ruins and level with the street, was a great bell of splendid tone, bearing the following inscription: " Claes Noorden Johan Albert de Grave me fecerunt Amstel — odamia, MDCCXIV."

Haweis mentions also the names of Bartholomews Goethale, 1680, who made a bell now in St. Stephen's belfry at Ghent; and another, Andrew Steilert, 1563, at Malines (Mechlin). The great carillon in the belfry at Bruges, thus far spared by the iconoclasts of 1914, consisting of forty bells and one large Bourdon, or triumphal bell, is from the foundry of the great Dumery, who also made the carillon at Antwerp.

Haweis credits Petrus Hemony, 1658, with being the most prolific of all the bell founders. He was a good musician and took to bell founding only late in life. " His small bells are exceedingly fine, but his larger ones are seldom true."

To the ear of so eminent an authority this may be true, but, to my own, the bells seem quite perfect, and I have repeatedly and most attentively listened to them from below in the Grand' Place, trying to discover the inharmonious note that troubled him. I ventured to ask one of the

49

priests if he had noticed any flatness in the notes, and he scorned the idea, saying that the bells, "all of them," were perfect.

Nevertheless, I must accept the statement of Haweis, who for years made a study of these bells and their individualities and than whom perhaps never has lived a more eminent authority.

From my room in the small hotel de Buda, just beneath the old gray tower of St. Rombauld in this ancient town of Malines, I have listened by day and night to the music of these bells, which sounded so exquisite to me that I can still recall them. The poet has beautifully expressed the idea of the bell music of Flanders thus, " The Wind that sweeps over her campagnas and fertile levels is full of broken melodious whispers " (Haweis).

Certainly these chimes of bells playing thus by day and night, day in, day out, year after year, must exercise a most potent influence upon the imagination and life of the people.

The Flemish peasant is born, grows up, lives his life out, and finally is laid away to the music of these ancient bells.

When I came away from Malines and reached Antwerp, I lodged in the Place Verte, as near to the chimes as I could get. My student days being over, I found that I had a strange sense of loss, as if I had lost a dear and

The Old Porte Marechale: Bruges

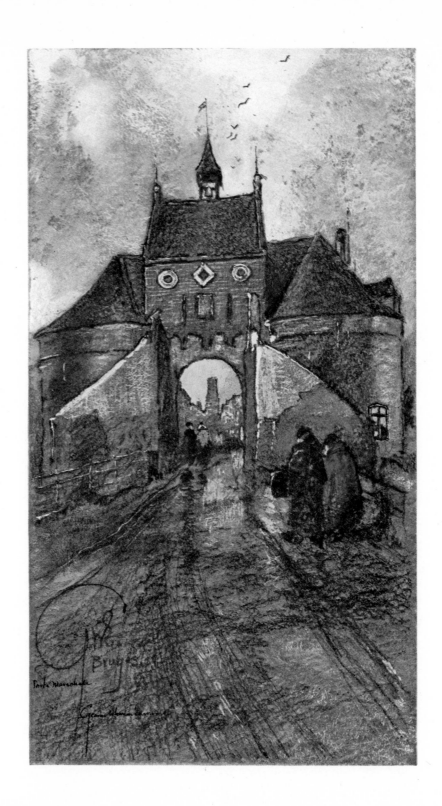

valued friend, for the sound of the bells had become really
a part of my daily existence.

Victor Hugo, who traveled through Flanders in 1837,
stopped for a time in Malines, and was so impressed with
the carillon that he is said to have written there the fol-
lowing lines by moonlight with a diamond upon the win-
dow-pane in his room:

> " J'aime le carillon dans tes cités Antiques,
> O vieux pays, gardien de tes moeurs domestiques,
> Noble Flandre, où le Nord se réchauffe engourdi
> Au soleil de Castille et s'accouple au Midi.
> Le carillon, c'est l'heure inattendue et folle
> Que l'oeil croit voir, vêtue en danseuse espagnole
> Apparaître soudain par le trou vif et clair
> Que ferait, en s'ouvrant, une porte de l'air."

It was not until the seventeenth century that Flanders
began to place these wondrous collections of bells in her
great towers, which seem to have been built for them.
Thus came the carillons of Malines, Bruges, Ghent, Ant-
werp, Louvain, and Tournai. Of these, Antwerp pos-
sessed the greatest in number, sixty-five bells. Malines
came next with forty-four, then Bruges with forty, and a
great bourdon or bass bell; then Tournai and Louvain
with forty, and finally Ghent with thirty-nine.

In ancient times these carillons were played by hand
on a keyboard, called a *clavecin*. In the belfry at Bruges,
in a dusty old chamber with a leaden floor, I found a very

old *clavecin*. It was simply a rude keyboard much like that of a primitive kind of organ, presenting a number of jutting handles, something like rolling pins, each of which was attached to a wire operating the hammer, in the bell chamber overhead, which strikes the rim of the bells. There was an old red, leather-covered bench before this machine on which the performer sat, and it must have been a task requiring considerable strength and agility so to smite each of these pins with his gloved fist, his knees and each of his feet (on the foot board) that the hammers above would fall on the rims of the different bells.

From my room in the old " Panier d'or " in the market-place on many nights have I watched the tower against the dim sky, and seen the light of the " *veilleur*," shining in the topmost window, where he keeps watch over the sleeping town, and sounds two strokes upon a small bell after each quarter is struck, to show that he is on watch. And so passed the time in this peaceful land until that fatal day in August, 1914.

Dixmude

Dixmude

THERE is no longer a Grand' Place at Dixmude. Of the town, the great squat church of St. Martin, and the quaint town hall adjoining it, now not one stone remains upon another. The old mossy walls and bastion are level with the soil, and even the course of the small sluggishly flowing river Yser is changed by the ruin that chokes it.

I found it to be a melancholy, faded-out kind of place in 1910, when I last saw it. I came down from Antwerp especially to see old St. Martin's, which enshrined a most wondrous *Jube*, or altar screen, and a chime of bells from the workshop of the Van den Gheyns. There was likewise on the Grand' Place, a fine old prison of the fourteenth century, its windows all closed with rusty iron bars, most of which were loose in the stones. I tried them, to the manifest indignation of the solitary gendarme, who saw me from a distance across the Grand' Place and hurried over to place me under arrest. I had to show him not only my passport but my letter of credit and my

55

sketch book before he would believe that I was what I claimed to be, a curious American, and something of an antiquary. But it was the sketch book that won him, for he told me that he had a son studying painting in Antwerp at the academy. So we smoked together on a bench over the bridge of the " Pape Gaei " and he related the story of his life, while I made a sketch of the silent, grass-grown Grand' Place and the squat tower of old St. Martin's, and the Town Hall beside it.

While we sat there on the bench only two people crossed the square, that same square that witnessed the entry of Charles the Fifth amid the silk- and velvet-clad nobles and burghers, and the members of the great and powerful guilds, which he regarded and treated with such respect. In those days the town had a population of thirty thousand or more. On this day my friend the gendarme told me that there were about eleven hundred in the town. Of this eleven hundred I saw twelve market people, the *custode* of the church of St. Martin; ditto that of the Town Hall; the gendarme; one baby in the arms of a crippled girl, and two gaunt cats.

The great docks to which merchantmen from all parts of the earth came in ships in the sixteenth and seventeenth centuries had now vanished, and long green grass waved in the meadows where the channel had been.

The ancient corporations and brotherhood, formerly of

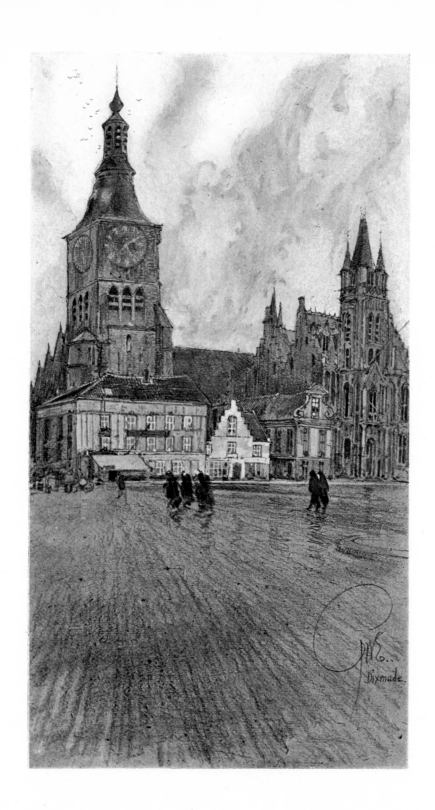

Dixmude.

such power and renown, had likewise long since vanished, and nought remained but here and there on the silent, grass-grown streets gray, ancient palaces with barred and shuttered windows. The very names of those who once dwelt there could be found only in the musty archives in Bruges or Brussels. A small *estaminet* across the bridge bore the sign " In den Pape Gaei," and to this I fared and wrote my notes, while the crippled girl carrying the baby seated herself where she could watch me, and then lapsed into a sort of trance, with wide open eyes which evidently saw not.

In company with a large, black, savage-looking dog which traveled side-ways regarding me threateningly, I thought, and gloweringly refused my offers of friendship, I crossed the Grand' Place to the Hotel de Ville, or Town Hall, the door of which stood open. Inside, no living soul responded to my knock. The rooms were rather bare of furniture, many of them of noble proportions, and a few desks and chairs showed that they were used by the town officers, wherever they were.

St. Martin's was closed, and I skirted its walls, hoping to find somewhere a door unfastened that I might enter and see the great *Jube* or altar screen. In a small, evil-smelling alley-way, where there was a patch of green grass, I saw low down in the wall a grated window, which I fancied must be at the back of the altar. I got down

on my knees and, parting the grass which grew there rankly, I put my face in against the iron bars that closed it. For a moment I could see nothing, then when my eyes became accustomed to the light I saw a tall candle burning on an iron ring on the wall; then a heavy black cross beside it, and finally a figure in some sort of heavy dark robe kneeling prostrate before it, only the tightly clasped white hands gleaming in the dim candle light; almost holding my breath I withdrew my head, feeling that I was almost committing sacrilege. Unfortunately for me, I dislodged some loose mortar, and I heard this rattle noisily into the chamber below. Then I fled as rapidly as I could down the dim alley-way to the silent sunlit Grand' Place. Here I found the verger, and he admitted me to the great old church, in return for a one-franc piece, and brought me a rush-bottom chair to a choice spot before the wondrous *Jube*, where I made my drawing.

In the silence of the great gray old church I labored over the exquisite Gothic detail, all unmindful of the passing time, when all at once I became conscious that a small green door beside the right hand low *retable* was moving outward. I ceased working and watched it; then the solitary candle before the statue of the Virgin guttered and flared up; then the small door opened wide and forth came an old man in a priest's cassock, with a staff in his hand. The small, green, baize-covered door closed

The Great Jube, or Altar Screen: Dixmude

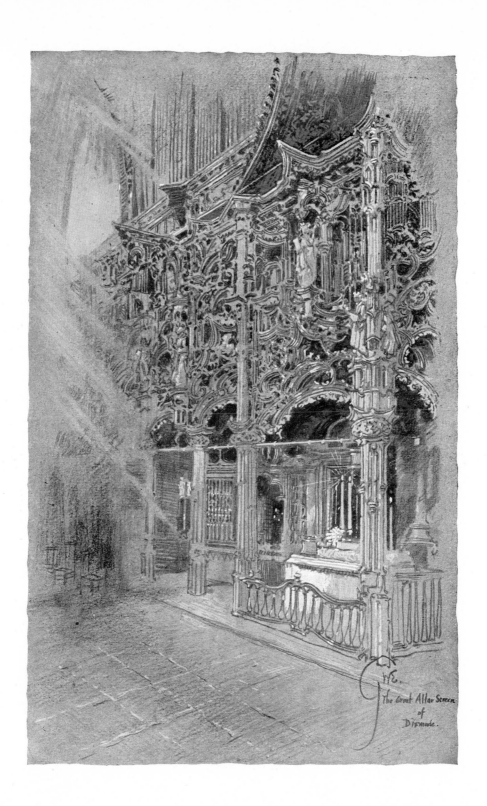

The Great Altar Screen
of
Dixmude.

noiselessly; the old man slowly opened the gate before the altar and came down the step toward me. Without a word he walked behind my chair and peered over my shoulder at the drawing I was making of the great *Jube*.

He tapped the floor with his staff, placed it under his arm, sought his pocket somewhere beneath his cassock, from which he produced a snuff box. From this he took a generous pinch, and a moment later was blowing vigorously that note of satisfaction that only a devotee of the powder can render an effective adjunct of emotion.

"Bien faite, M'sieur," he exclaimed at length, wiping his eyes on a rather suspicious looking handkerchief. "T-r-r-r-es bien faite! J'vous fais mes compliments." "Admirable! You have certainly rendered the spirit of our great and wondrous altar screen."

A little later we passed out of the old church through a side door leading into a small green enclosure, now gloomy in the shade of the old stone walls. At one end was a tangle of briar, and here were some old graves, each with a tinsel wreath or two on the iron cross. And presiding over these was the limp figure of a one-legged man on two crutches, who saluted us. We passed along to the end of the inclosure, where lay a chance beam of sunshine like a bar of dusty gold against the rich green grass.

"Oui, M'sieur," said the priest, as if continuing a sentence he was running over in his mind. " Cassé! Pauvre Pierre, un peu cassé, le pauvre bonhomme, but then, he's good for several years yet; cracked he is, but only cracked like a good old basin, and (in the idiom) he'll still hold well his bowl of soup."

He laughed at his wit, became grave, then shook out another laugh.

" See," he added, pointing to the ground all about us strewn with morsels of tile; " the roof cracks, but it still holds," he added, pointing upwards at the old tower of St. Martin's. " And now, M'sieur, I shall take you to my house; *tenez*, figure to yourself," and he laid a fine, richly veined, strong old hand upon my arm with a charming gesture. " I have been here twenty-five years; I bought all the antique furniture of my predecessor. I said to myself, ' Yes, I shall buy the furniture for five hundred francs, and then, later I shall sell to a wealthy amateur for one thousand francs, perhaps in a year or two.' Twenty-five years ago, and I have it yet. And now it creaks and creaks and snaps in the night. We all creak and creak thus as we grow old; ah, you should hear my wardrobes. ' Elles cassent les dos,' and I lie in my warm bed in the winter nights and listen to my antiques groan and complain. Poor old things, they belonged to the ' Empire ' Period; no wonder they groan.

The Fish Market: Dixmude

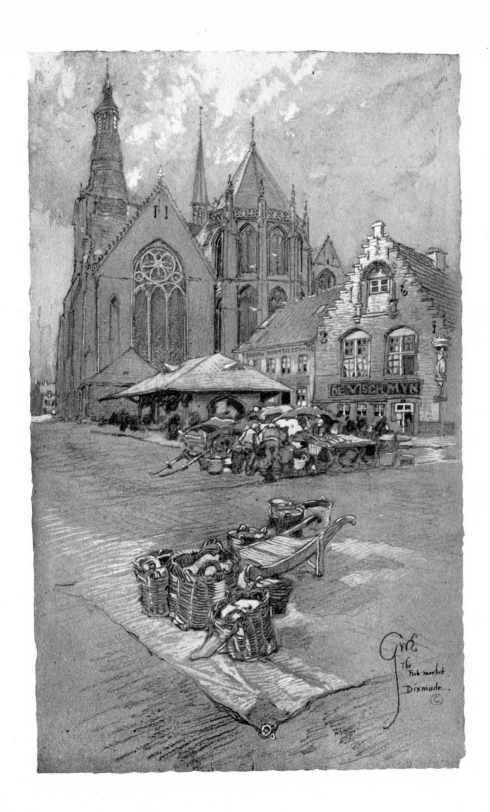

The Fish market.
Dixmude.

DIXMUDE

"And when my friend the notaire comes to play chess with me, you should see him eye my antiques, ah, so covetously; I see him, but I never let on. Such a collection of antiques as we all are, M'sieur." Then he became serious, and lifting his cane he pointed to a gravestone at one side, "My old servant lies there, M'sieur; we are all old here now, but still we do not die. Alas! we never die. There is plenty of room here for us, but we die hard. See, myotis, heliotrope, hare bells, and mignonette, a bed of perfume, and there lies my old servant. A restless old soul she was, and she took such a long time to die. She was eighty-five when she finally made up her mind."

I had a cup of wine with the old man in his small *salle à manger*. His house was indeed a mine of wealth for the antiquary and collector, more like a shop than a house. I lingered with him for nearly an hour, telling him of the great world lying beyond Dixmude, of London and Paris, and of New York and some of its wonders, of which I fancied he was rather sceptical. And then I came away, after shaking hands with him at his doorstep in the dim alley-way, with the bar of golden sunlight shining at the entrance to the Grand' Place and the noise of the rooks cawing on the roof.

"*Au revoir*, M'sieur le Peintre, *et bon voyage*, and remember, 'Ask, and it shall be given, seek and you shall find,'" and with these cryptic words, he stood with up-

lifted hands, a smile irradiating his fine ascetic face glowing like that of a saint. Behind the faded black of his old *soutane* I could see his treasures of blue china and ancient cabinets, and a chance light illumined a mirror behind his head, and aureoled him like unto one of the saints behind the great " Jube," and thus I left him.

And now Dixmude is in formless heaps of ashes and burnt timbers. Hardly one stone now remains upon another. There is no longer a Grand' Place — and the very course of the river Yser is changed.

Ypres

Ypres

YPRES as a town grew out of a rude sort of stronghold built, says M. Vereeke in his "Histoire Militaire d'Ypres," in the year 900, on a small island in the river Yperlee. It was in the shape of a triangle with a tower on each corner, and was known to the inhabitants as the "Castle of the three Turrets."

Its establishment was followed by a collection of small huts on the banks of the stream, built by those who craved the protection of the fortress. They built a rampart of earth and a wide ditch to defend it, and to this they added from time to time until the works became so extensive that a town sprang into being, which from its strategic position on the borders of France soon became of great importance in the wars that constantly occurred. Probably no other Flemish town has seen its defenses so altered and enlarged as Ypres has between the primitive days when the crusading Thierry d'Alsace planted hedges of live thorns to strengthen the towers, and the formation of the great works of Vauban. We have been so ac-

65

customed to regárding the Fleming as a sluggish boor, that it comes in the nature of a surprise when we read of the part these burghers, these weavers and spinners, took in the great events that distinguished Flemish history. "In July, 1302, a contingent of twelve hundred chosen men, five hundred of them clothed in scarlet and the rest in black, were set to watch the town and castle of Courtrai, and the old Roman Broël bridge, during the battle of the 'Golden Spurs,' and the following year saw the celebration of the establishment of the confraternity of the Archers of St. Sebastian, which still existed in Ypres when I was there in 1910. This was the last survivor of the famed, armed societies of archers which flourished in the Middle Ages. Seven hundred of these men of Ypres embarked in the Flemish ships which so harassed the French fleet in the great naval engagement of June, 1340."

Forty years later five thousand men of Ypres fought upon the battlefield with the French, on that momentous day which witnessed the death of Philip Van Artevelde and the triumph of Leliarts. Later, when the Allies laid siege to the town, defended by Leliarts and Louis of Maele, it was maintained by a force of ten thousand men, and on June 8, 1383, these were joined by seventeen thousand English and twenty thousand Flemings, these latter from Bruges and Ghent.

YPRES

At this time the gateways were the only part of the fortifications built of stone. The ramparts were of earth, planted with thorn bushes and interlaced with beams. Outside were additional works of wooden posts and stockades, behind the dyke, which was also palisaded. The English, believing that the town would not strongly resist their numbers, tried to carry it by assault. They were easily repulsed, to their great astonishment, with great losses.

At last they built three great wooden towers on wheels filled with soldiers, which they pushed up to the walls, but the valiant garrison swarmed upon these towers, set fire to them, and either killed or captured those who manned them.

All the proposals of Spencer demanding the surrender of Ypres were met with scorn, and the English were repeatedly repulsed with great losses of men whenever they attempted assaults.

The English turned upon the Flemish of Ghent with fury, saying that they had deceived them as to the strength of the garrison of Ypres, and Spencer, realizing that it was impossible to take the town before the French army arrived, retired from the field with his soldiers. This left Flanders at the mercy of the French. But now ensued the death of Count Louis of Maele (1384) and this brought Flanders under the rule of the House of

Burgundy, which resulted in prosperity and well nigh complete independence for the Flemings.

The Great Kermesse of Our Lady of the Garden (Notre Dame de Thuine) was then inaugurated because the townspeople believe that Ypres had been saved by the intercession of the Virgin Mary — the word Thuin meaning in Flemish " an enclosed space, such as a garden plot," an allusion to the barrier of thorns which had so well kept the enemy away from the walls — a sort of predecessor of the barbed-wire entanglements used in the present great world war.

The Kermesse was held by the people of Ypres on the first Sunday in August every year, called most affectionately " Thuindag," and while there in 1910 I saw the celebration in the great square before the Cloth Hall, and listened to the ringing of the chimes; the day being ushered in at sunrise by a fanfare of trumpets on the parapet of the tower by the members of a local association, who played ancient patriotic airs with great skill and enthusiasm.

In the Place de Musée, a quiet, gray corner of this old town, was an ancient Gothic house containing a really priceless collection of medals and instruments of torture used during the terrible days of the Spanish Inquisition. I spent long hours in these old musty rooms alone, and I might have stolen away whatever took my fancy had I

been so minded, for the *custode* left me quite alone to wander at will, and the cases containing the seals, parchments, and small objects were all unfastened.

I saw the other day another wonderful panorama photograph taken from an aeroplane showing Ypres as it now is, a vast heap of ruins, the Cloth Hall gutted; the Cathedral leveled, and the site of the little old museum a vast blackened hole in the earth where a shell had landed. The photograph, taken by an Englishman, was dated September, 1915.

The great Hanseatic League, that extensive system of monopolies, was the cause of great dissatisfaction and many wars because of jealousy and bad feeling. Ypres, Ghent, and Bruges, while defending their rights and privileges against all other towns, fought among themselves. The monopoly enjoyed by the merchant weavers of Ypres forbade all weaving for " three leagues around the walls of Ypres, under penalty of confiscation of the looms and all of the linen thus woven."

Constant friction was thus engendered between the towns of Ypres and Poperinghe, resulting in bloody battles and the burning and destruction of much property. Even within the walls of the town this bickering went on from year to year. When they were not quarreling with their neighbors over slights or attacks, either actual or fancied, they fought among themselves over the eternal

question of capital *versus* labor. A sharp line was drawn between the workingman and the members of the guilds who sold his output. The artisans, whose industry contributed so greatly to the prosperity of these towns, resented any infringement of their legal rights. The merchant magistrates were annually elected, and on one occasion, in 1361, to be exact, because this was omitted, the people arose in their might against the governors, who were assembled in the Nieuwerck of the Hotel de Ville. The Baillie, one Jean Deprysenaere, haughty in his supposed power, and trusting in his office, as local representative of the Court of Flanders, appeared before the insurgent weavers and endeavored to appease them. " They fell upon him and slew him " (Vereeke). Then, rushing into the council chamber, they seized the other magistrates and confined them in the belfry of the Cloth Hall.

" Then the leaders in council resolved to kill the magistrates, and beheaded the Burgomaster and two sheriffs in the place before the Cloth Hall in the presence of their colleagues " (Vereeke).

Following the custom of the Netherlands, each town acted for itself alone. The popular form of government was that of gatherings in the market-place where laws were discussed and made by and for the people. The spirit of commercial jealousy, however, kept them apart

and nullified their power. Consumed by the thirst for commercial, material prosperity, they had no faith in each other, no bond of union, each being ready and willing to foster its own interest at its rival's expense. Thus neither against foreign nor internal difficulties were they really united. The motto of modern Belgium, " L'Union fait la Force," was not yet invented, and there was no great and powerful authority in which they believed and about which they could gather.

This history presents the picture of Ghent assisting an army of English soldiers to lay siege to Ypres. So the distrustful people dwelt amid perpetual quarreling, trade pitted against trade, town against town, fostering weakness of government and shameful submission in defeat. No town suffered as did Ypres during this distracted state of affairs in Flanders of the sixteenth century, which saw it reduced from a place of first importance to a dead town with the population of a village. And so it remained up to the outbreak of the world war in 1914.

This medieval and most picturesque of all the towns of Flanders had not felt the effect of the wave of restoration, which took place in Belgium during the decade preceding the outbreak of the world war, owing to the fact that its monuments of the past were perhaps finer and in a better state of preservation than those of any of the other ancient towns. Ypres in the early days had treated the

71

neighboring town of Poperinghe with great severity through jealousy, but she in turn suffered heavily at the hands of Ghent in 1383–84 when the vast body of weavers fled, taking refuge in England, and taking with them all hope of the town's future prosperity.

Its decline thenceforward was rapid, and it never recovered its former place in the councils of Flanders. Its two great memorials of the olden times were the great Cloth Hall, in the Grand' Place, and the Cathedral of Saint Martin, both dating from the twelfth and thirteenth centuries.

The Cloth Hall, begun by Count Baldwin IX of Flanders, was perhaps the best preserved and oldest specimen of its kind in the Netherlands, and was practically complete up to the middle of August, 1915, when the great guns of the iconoclastic invader shot away the top of the immense clock tower, and unroofed the entire structure. Its façade was nearly five hundred feet long, of most severe and simple lines, and presented a double row of ogival windows, surmounted by niches containing thirty-one finely executed statues of counts and countesses of Flanders. There were small, graceful turrets at each end, and a lofty belfry some two hundred and thirty feet in height in the center, containing a fine set of bells connected with the mechanism of a carillon.

The interior of the hall was of noble proportions, run-

No. 4, Rue de Dixmude: Ypres

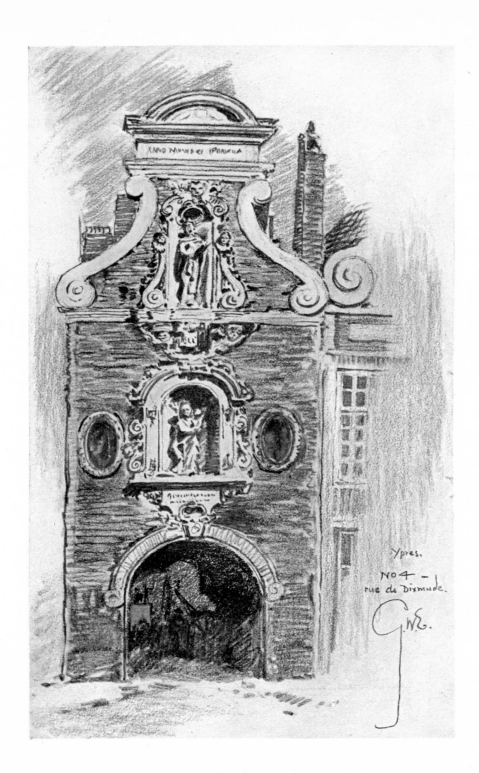

Ypres.

No 4 —
rue de Dixmude.

G.W.E.

ning the full length, its walls decorated by a series of paintings by two modern Flemish painters, which were not of the highest merit, yet good withal. At the market-place end was a highly ornate structure called the New Work (Nieuwerke), erected by the burghers as a guild-hall in the fifteenth century. This was the first part of the edifice to be ruined by a German shell.

The destruction of this exquisite work of art seems entirely wanton and unnecessary. It produced no result whatever of advantage. There were neither English, French, nor Belgian soldiers in Ypres at the time. The populace consisted of about ten thousand peaceful peasants and shopkeepers, who, trusting in the fact that the town was unarmed and unfortified, remained in their homes. The town was battered and destroyed, leveled in ashes. The bombardment destroyed also the great Cathedral of Saint Martin adjoining the Cloth Hall, which dated from the thirteenth century [although the tower was not added until the fifteenth century]. It formed a very fine specimen of late Gothic, the interior containing some fine oak carving and a richly carved and decorated organ loft. Bishop Jansenius, the founder of the sect of Jansenists, is buried in a Gothic cloister which formed a part of the older church that occupied the site.

Another interesting monument of past greatness was the Hotel de Ville, erected in the sixteenth century, and

containing a large collection of modern paintings by French and Belgian artists. Of this structure not a trace remains save a vast blackened pile of crumbled stones and mortar. In the market-place now roam bands of half-starved dogs in search of food; not a roof remains intact. A couple of sentries pace before the hospital at the end of the Grand' Place. A recent photograph in the *Illustrated London News* taken from an aeroplane shows the ruined town like a vast honeycomb uncovered, the streets and squares filled with débris, the fragments of upstanding walls showing where a few months ago dwelt in peace and prosperity an innocent, happy people, now scattered to the four winds — paupers, subsisting upon charity. Their valiant and noble king and queen are living with the remnant of the Belgian army in the small fishing village of La Panne on the sand dunes of the North Sea.

The unique character of the half-forgotten town was exemplified by the number of ancient, wooden-faced houses to be found in the side streets. The most curious of these, perhaps, was that situated near the Porte de Lille, which I have mentioned in another page, and which noted architects of Brussels and Antwerp vainly petitioned the State to protect, or to remove bodily the façade and erect it in one of the vast "Salles" of the Cloth Hall. Both MM. Pauwels and Delbeke, the mural painters, then engaged in the decorations of the Cloth Hall,

74

joined in protests to the authorities against their neglect of this remarkable example of medieval construction, but all these petitions were pigeonholed, and nothing resulted but vain empty promises, so the matter rested, and now this beautiful house has vanished forever.

The great mural decorations of the " Halles " were nearly completed by MM. Delbeke and Pauwels, when they both died within a few months of each other, in 1891. In these decorations the artists traced the history of Ypres from 1187 to 1383, the date of the great siege, showing taste and elegance in the compositions, notably in that called the " Wedding feast of Mahaut, daughter of Robert of Bethune, with Mathias of Lorraine (1314)."

One of the panels by M. Pauwels showed most vividly the progress of the " Pest," under the title of the " Mort d'Ypres " (*de Dood van Yperen*, Flemish). It represented the " Fossoyeur " calling upon the citizens upon the tolling of the great bell of St. Martin's, to bring out their dead for burial.

M. Delbeke's talent was engaged upon scenes illustrating the civil life of the town, the gatherings in celebration of the philanthropic and intellectual events in its remarkable history, a task in which he was successful in spite of the carping of envious contemporaries.

A committee of artists was appointed to examine his work, and although this body decided in his favor, it may

be that the criticism to which he was subjected hastened his death. At any rate the panels remained unfinished, no other painter having the courage to carry out the projected work.

The original sketches for these great compositions were preserved in the museum of the town, but the detailed drawings, some in color, were, up to the outbreak of the war in 1914, in the Museum of Decorative Arts in Brussels, together with the cartoons of another artist, Charles de Groux (1870), to whom the decoration of the Halles had been awarded by the State in competition. A most sumptuous Gothic apartment was that styled the " Salle Echevinale," restored with great skill in recent years by a concurrence of Flemish artists, members of the Academy. Upon either side of a magnificent stone mantel, bearing statues in niches of kings, counts and countesses, bishops and high dignitaries, were large well executed frescoes by MM. Swerts and Guffens, showing figures of the evangelists St. Mark and St. John, surrounded by myriads of counts and countesses of Flanders, from the time of Louis de Nevers and Margaret of Artois to Charles the Bold, and Margaret of York, whose tombs are in the Cathedral at Bruges. The attribution of these frescoes to Melchior Broederlam does not, it would seem, accord with the style or the date of their production, M. Alph. van den Peere-

Arcade of the Cloth Hall: Ypres

Arcade of the Cloth Hall : Ypres

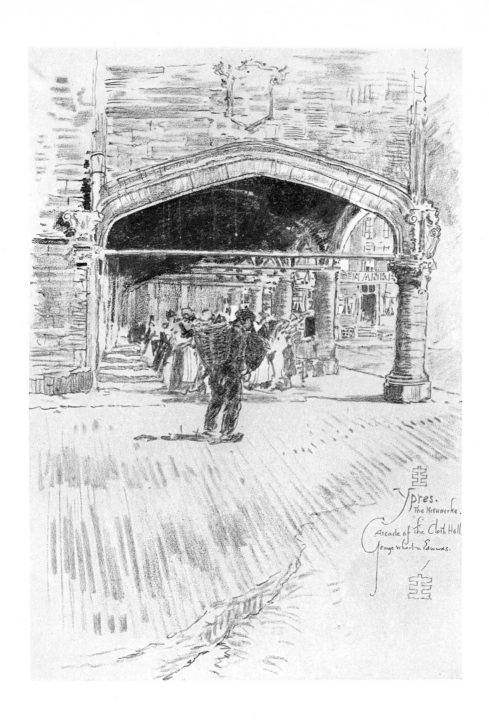

Ypres.
The Nieuwerke.
Arcade of the Cloth Hall
George Wharton Edwards.

boom thinks, and he gives credit for the work to two painters who worked in Ypres in 1468 — MM. Pennant and Floris Untenhoven.

In my search for the curious and picturesque, I came, one showery day, upon a passageway beneath the old belfry which led to the tower of St. Martin's. Here one might believe himself back in the Middle Ages. On both sides of the narrow street were ancient wooden-fronted houses not a whit less interesting or well preserved than that front erected in the chamber of the " Halles." This small dark street led to a vast and solitary square. On one side were lofty edifices called the Colonnade of the " Nieuwerck," at the end of which was a quaint vista of the Grand' Place. On the other side was a range of most wondrous ancient constructions; the *conciergerie* and its attendant offices, bearing finials and gables of astonishing richness of character, and ornamented with *chefs-d'œuvres* of iron-work, marking the dates of erection, all of them prior to 1616. In this square not a soul appeared, nor was there a sound to be heard save the cooing of some doves upon a rooftree, although I sat there upon a stone coping for the better part of a half hour. Then all at once, out of a green doorway next the *conciergerie*, poured a throng of children, whose shrill cries and laughter brought me back to the present. One won-

ders where now are these merry light-hearted little ones, who thronged that gray grass-grown square behind the old Cloth Hall in 1912. . . .

In this old square I studied the truly magnificent south portal and transept of St. Martin's, the triple portal with its splendid polygonal rose window, and its two graceful slender side towers, connecting a long gallery between the two smaller side portals. One's impression of this great edifice is that of a sense of noble proportions, rather than ornateness, and this is to be considered remarkable when one remembers the different epochs of its construction. That the choir was commenced in 1221 is established by the epitaph of Hugues, *prévôt* of St. Martin's, whose ashes reposed in the church which he built: that the first stone of the nave transepts was laid with ceremony by Marguerite of Constantinople in 1254; that the south portal was of the fifteenth century and that a century later the chapel called the *doyen* toward the south wall at the foot of the tower, was erected. The tower itself, visible from all parts of the town, was the conception of Martin Untenhoven of Malines, and replaced a more primitive one in 1433. Of very severe character, its great bare bulk rose to an unfinished height of some hundred and seventy feet, and terminated in a squatty sort of pent-house roof of typical Flemish char-

78

acter. It was flanked by four smaller, unfinished towers, one at each corner. This tower, one may recall, figures in many of the pictures of Jean van Eyck. It is not without reason that Schayes, in his " Histoire de l'Architecture en Belgique," speaks of the choir of St. Martin's as " one of the most remarkable of the religious constructions of the epoch in Belgium." Of most noble lines and proportion if it were not for the intruding altar screen in the Jesuit style, which mars the effect, the ensemble were well-nigh perfect.

Its decoration, too, was remarkable. A fresco at the left of the choir, with a portrait of Robert de Bethune, Count of Flanders, who died at Ypres in 1322 and was buried in the church, was uncovered early in the eighties during a restoration; this had been most villainously repainted by a local " artist " (?) ; and I mortally offended the young priest who showed it to me, by the vehemence of my comments.

The stalls of the choir, in two banks or ranges, twenty-seven above, twenty-four below, bore the date of 1598, and the signature of d'Urbain Taillebert, a native sculptor of great merit, who also carved the great *Jube* of Dixmude (see drawing). Other works of Taillebert are no less remarkable, notably the superb arcade with the Christ triumphant suspended between the columns at

the principal entrance. He was also the sculptor of the mausoleum of Bishop Antoine de Hennin, erected in 1622 in the choir.

In the pavement before the altar a plain stone marked the resting place of the famous Corneille Jansen (Cornelius Jansenius), seventh Bishop of Ypres, who died of the pest the 6th of May, 1638. One recalls that the doctrine of Jansen gave birth to the sect of that name which still flourishes in Holland.

Following the Rue de Lille one came upon the old tower of St. Pierre, massed among tall straight lines of picturesque poplars, its bulk recalling vaguely the belfry of the Cloth Hall. In this church was shown a curious little picture, representing the devil setting fire to the tower, which was destroyed in 1638, but was later rebuilt after the original plans. The interior had no dignity of style whatever. There were, however, some figures of the saints Peter and Paul attributed to Carel Van Yper, which merited the examination of connoisseurs. They are believed by experts to have been the " volets " of a triptych of which the center panel was missing.

The Place St. Pierre was picturesque and smiling. Following this route we found on the right at the end of a small street the hospital St. Jean, with an octagonal tower, which enshrined some pictures attributed to the prolific Carel Van Yper, comment upon which would be

Gateway, Wall, and Old Moat: Ypres

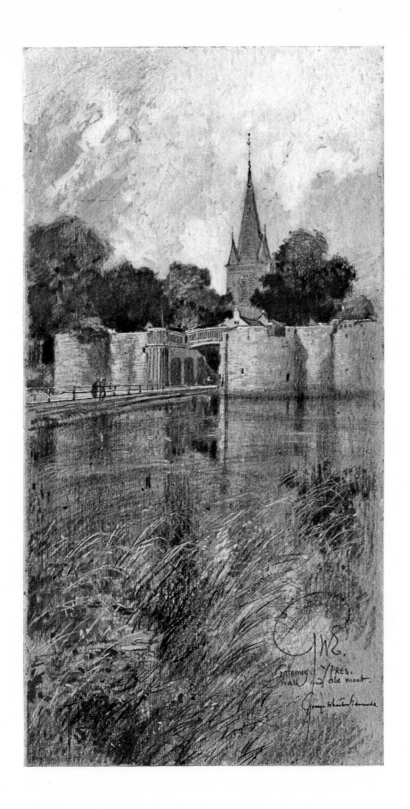

Gateway Wall and old moat. YPRES.

George Walter Edwards.

perhaps out of place here. On the corner of this street was a most charming old façade in process of demolishment, which we deplored.

Now we reached the Porte de Lille again and the remains of the old walls of the town. Again and again we followed this same route, each time finding some new beauty or hidden antiquity which well repaid us for such persistence. Few of the towns of Flanders presented such treasures as were to be found in Ypres. Following the walk on the ramparts, past the *caserne* or infantry barracks, one came upon the place of the ancient château of the counts, a vast construction under the name of " de Zaalhof." Here was an antique building called the " Lombard," dated 1616, covered with old iron " ancres " and crosses between the high small-paned windows.

By the Rue de Beurre one regained the Grand' Place, passing through the silent old Place Van den Peereboom in the center of which was the statue of the old Burgomaster of that name.

The aspect of this silent grass-grown square behind the Cloth Hall was most impressive. Here thronged the burghers of old, notably on the occasion of the entry of Charles the Bold and his daughter Marguerite, all clad in fur, lace, and velvet to astonish the inhabitants, who instead of being impressed, so outshone the visitors, by

their own and their wives' magnificence of apparel, that Marguerite was reported to have left the banquet hall in pique. The belfry quite dominated the square at the eastern angle, where were the houses forming the *conciergerie*.

Turning to the right by way of the Chemin de St. Martin, one found the ancient Beguinage latterly used by the gendarmerie as a station, the lovely old chapel turned into a stable! In this old town were hundreds of remarkable ancient houses, each of which merits description in this book. But perhaps in this brief and very fragmentary description the reader may find reason for the author's enthusiasm, and agree with him that Ypres was perhaps the most unique and interesting of all the destroyed towns in Flanders.

Commines

Commines

IT was not hard to realize that here we were in the country of Bras-de-Fer, of Memling, of Cuyp, and Thierry d'Alsace, for, on descending from the halting, bumping train at the small brick station, we were face to face with a bizarre, bulbous-topped tower rising above the houses surrounding a small square, and now quite crowded with large, hollow-backed, thick-legged Flemish horses, which might have been those of the followers of Thierry gathered in preparation for an onslaught upon one of the neighboring towns.

It seemed as though any turning might bring us face to face with a grim cohort of mounted armed men in steel corselet and morion, bearing the banner of Spanish Philip, so sinister were the narrow, ill-paved streets, darkened by the projecting second stories of the somber, gray-stone houses. Rarely was there an open door or window. As we passed, our footsteps on the uneven stones awakened the echoes. A fine drizzle of rain which began to fall upon us from the leaden sky did not tend to enliven us, and we hastened toward the small Grand' Place, where I

noted on a sign over a doorway the words, " In de Leeuw Van Vlanderen " (To the Flemish Lion), which promised at least shelter from the rainfall. Here we remained until the sun shone forth.

Commines (Flemish, Komen) was formerly a fortified town of some importance in the period of the Great Wars of Flanders. It was the birthplace of Philip de Commines (1445–1509). It was, so to say, one of the iron hinges upon which the great military defense system of the burghers swung and creaked in those dark days. Today, in these rich fields about the small town, one can find no traces of the old-time bastions which so well guarded the town from Van Artevelde's assaults. Inside the town were scarcely any trees, an unusual feature for Flanders, and on the narrow waterways floated but few craft.

The only remarkable thing by virtue of its Renaissance style of architecture was the belfry and clock tower, although some of the old Flemish dwelling houses in the market square, projecting over an ogival Colonnade extending round one end of the square, and covering a sort of footway, were of interest, uplifting their step-like gables as a silent but eloquent protest against a posterity devoid of style, all of them to the right and left falling into line like two wings of stone in order to allow the carved front of the belfry to make a better show, and its

pinnacled tower to rise the prouder against the sky.

"One was struck with the ascendency of the religious element over all forms of art, and this was a characteristic of the Flemings. One was everywhere confronted with a curious union of religion and war, representations peopled exclusively by seraphic beings surrounded or accompanied by armed warriors. Everything is adoration, resignation, incense fumes, psalmody, and crusaders. The greatest buildings we saw were ecclesiastical, the richest dresses were church vestments, even "the princes and burghers accompanied by armed knights remind one of ecclesiastics celebrating the Mass. All the women are holy virgins, seemingly. The chasm between the ideal and the reality itself, however idealized, but by meditation manifested pictorially." ("The Land of Rubens," C. B. Huet).

We sat for an hour in the small, sooty, tobacco-smelling *estaminet* (from the Spanish *estamento* — an inn), and then the skies clearing somewhat we fared forth to explore the belfry, which in spite of its sadly neglected state was still applied to civic use. Some dark, heavy, oaken beams in the ceiling of the principal room showed delicately carved, fancy heads, some of them evidently portraits. At the rear of the tower on the ground floor, I came upon a vaulted apartment supported on columns, and being used as a storehouse. Its construction was so

handsome, it was so beautifully lighted from without, as to make one grieve for its desecration; it may have served in the olden time as a refectory, and if so was doubtless the scene of great festivity in the time of Philip de Commines, who was noted for the magnificence of his entertainments.

The Flemish burghers of the Middle Ages first built themselves a church; when that was finished, a great hall. That of Ypres took more than two hundred years to complete. How long this great tower of Commines took, I can only conjecture. Its semi-oriental pear-shaped (or onion-shaped, as you will) tower was certainly of great antiquity; even the unkempt little priest whom I questioned in the Grand' Place could give me little or no information concerning it. Indeed, he seemed to be on the point of resenting my questions, as though he thought that I was in some way poking fun at him. I presume that it was the scene of great splendor in their early days. For here a count of Flanders or a duke of Brabant exercised sovereign rights, and at such a ceremony as the laying of a corner-stone assumed the place of honor, although the real authority was with the burghers, and founded upon commerce. While granting this privilege, the Flemings ever hated autocracy. They loved pomp, but any attempt to exercise power over them infuriated them.

" The architecture of the Fleming was the expression of

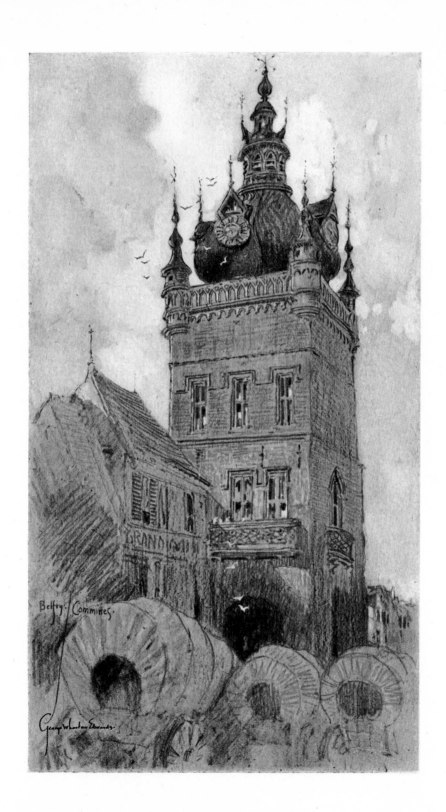

Belfry · Commines.

George Wharton Edwards

aspiration," says C. B. Huet ("The Land of Rubens").

"The Flemish hall has often the form of a church; art history, aiming at classification, ranges it among the Gothic by reason of its pointed windows. The Hall usually is a defenceless feudal castle without moats, without porticullis, without loopholes. It occupies the center of a market-place. It is a temple of peace, its windows are as numerous as those in the choirs of that consecrated to the worship of God.

"From the center of the building uprises an enormous mass, three, four, five stories high, as high as the cathedral, perhaps higher. It is the belfry, the transparent habitation of the alarm bell (as well as the chimes). The belfry cannot defend itself, a military character is foreign to it. But as warden of civic liberty it can, at the approach of domination from without, or autocracy uplifting its head within, awaken the threatened ones, and call them to arms in its own defence. The belfry is thus a symbol of a society expecting happiness from neither a dynasty nor from a military despotism, but solely from common institutions, from commerce and industry, from a citizen's life, budding in the shadow of the peaceful church, and borrowing its peaceful architecture from it. To the town halls of Flanders belonged the place of honor among the monuments of Belgian architecture. No other country of Europe offered so rich a variety in that respect.

VANISHED TOWERS OF FLANDERS

" Courtrai replaces Arras; Oudenaarde and Ypres follow suit. Then come Tournai, Bruges, Ghent, Antwerp, Brussels, Louvain. Primary Gothic, secondary Gothic, tertiary Gothic, satisfying every wish. Flanders and Brabant called the communal style into life. If ever Europe becomes a commune, the communards have but to go to Ypres to find motifs from their architects."

Since this was written, in 1914, many, if not most, of these great buildings thus enumerated above, are now in ruins, utterly destroyed for all time!

Bergues

Bergues

A TINY sleepy town among the fringe of great willow trees which marked the site of the ancient walls. Belted by its crumbling ramparts, and like a quaint gem set in the green enamel of the smiling landscape, it offered a resting place far from the cares and noise of the world.

Quite ignored by the guide books, it had, I found, one of the most remarkable belfries to be found in the Netherlands, and a chime of sweet bells, whose melodious sounds haunted our memories for days after our last visit in 1910.

There were winding, silent streets bordered by mysteriously closed and shuttered houses, but mainly these were small and of the peasant order. On the Grand' Place, for of course there was one, the tower sprang from a collection of rather shabby buildings, of little or no character, but this did not seem to detract from the magnificence of the great tower. I use the word "great" too often, I fear, but can find no other word in the language to qualify these "Campanili" of Flanders.

This one was embellished with what are known as

93

" ogival arcatures," arranged in zones or ranks, and there were four immense turrets, one at each corner, these being in turn covered with arcatures of the same character. These flanked the large open-work, gilded, clock face. Surmounting this upon a platform was a construction in the purely Flemish style, containing the chime of bells, and the machinery of the carillon, and topping all was a sort of inverted bulb or gourd-shaped turret, covered with blue slate, with a gilded weathervane about which the rooks flew in clouds.

The counterpart of this tower was not to be found anywhere in the Netherlands, and one is surprised that it was so little known.

Upon the occasion of our visit the town was given up to the heavy and stolid festivities of the "Kermesse," which is now of interest here only to the laboring class and the small farmers of the region. The center of attraction, as we found in several other towns, seemed to be an incredibly fat woman emblazoned on a canvas as the " Belle Heloise " who was seated upon a sort of throne draped in red flannel, and exhibited a pair of extremities resembling in size the masts of a ship, to the great wonder of the peasants. There were also some shabby merry-go-rounds with wheezy organs driven by machinery, and booths in which hard-featured show women were frying waffles in evil smelling grease. After buying some

94

The Towers of St. Winoc: Bergues

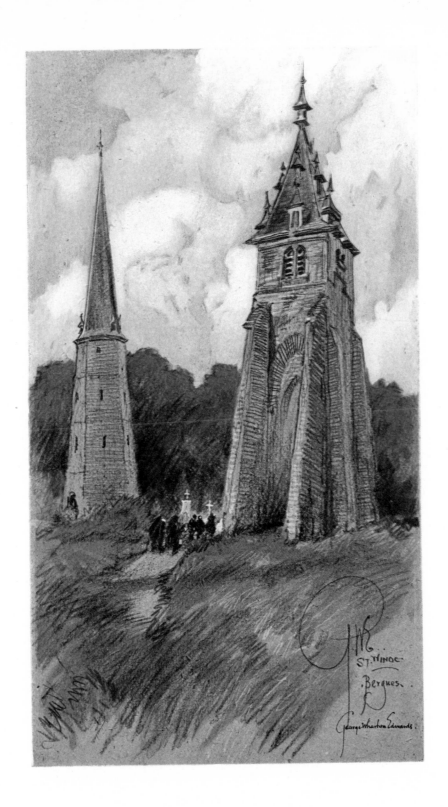

ST. WINOC.
Bergues.

George Wharton Edwards

of these for the children who stood about with watering mouths, we left the "Kermesse" and wandered away down a silent street towards a smaller tower rising from a belt of dark trees.

This we found to be the remains of the ancient abbey of St. Winoc. A very civil mannered young priest who overtook us on the road informed us of this, and volunteered further the information that we were in what was undoubtedly the ancient *jardin-clos* of the Abbey. Of this retreat only the two towers standing apart in the long grass remained, one very heavy and square, supported by great buttresses of discolored brick, the other octangular, in stages, and retaining its high graceful steeple.

We were unable to gain entrance to either of these towers, the doorways being choked with weeds and the débris of fallen masonry. [The invaders destroyed both of these fine historical remains in November, 1914, alleging that they were being used for military observation by the Belgian army.] These small towns of Flanders had a simple dignity of their own which was of great attraction to the tourist, who could, without disillusionment, imagine himself back in the dim past. In the wayside inns or *estaminets* one could extract amusement and profit listening to the peasantry or admiring the sunlight dancing upon the array of bottles and glass on the leaden counters, or watch

the peasants kneel and cross themselves before the invariable quaint niched figure of the Virgin and Child under the hanging lighted lantern at a street corner, the evidence of the piety of the village, or the throngs of lace-capped, rosy-cheeked milkmaids with small green carts drawn by large, black, " slobbering " dogs of fierce mien, from the distant farms, on their way to market.

Thus the everyday life of the region was rendered poetic and artistic, and all with the most charming unconsciousness.

Nieuport

Nieuport

IN the midst of a level field to the east of the town of Nieuport in 1914 was a high square weather-beaten tower, somewhat ruinous, built of stone and brick in strata, showing the different eras of construction in the various colors of the brick work ranging from light reds to dark browns and rich blacks. This tower, half built and square topped, belonged to a structure begun in the twelfth century, half monastery, half church, erected by the Templars as a stronghold. Repeatedly attacked and set on fire, it escaped complete destruction, although nearly laid in ruins by the English and burghers of Ghent in 1383, the year of the famous siege of Ypres. During the Wars of 1600, it was an important part of the fortifications, and from the platform of its tower the Spanish garrison commanded a clear view of the surrounding country and the distance beyond the broad moat, which then surrounded the strong walls of Nieuport.

In plain view from this tower top were the houses of Furnes, grouped about the church of Saint Nicolas to the

southwest, while to the north the wide belt of dunes, or sand hills, defended the plains from the North Sea. Nearer were the populous villages of Westende and Lombaerd-Zyde, connected with Nieuport by numerous small lakes and canals derived from the channel of the Yser river, which flowed past the town on its way to the sea.

The history of Nieuport, from the terrible days of the Spanish invasion down to these days of even worse fate, has been pitiable. Its former sea trade after the Spanish invasion was never recovered, and its population, which was beginning to be thrifty and prosperous up to 1914, has now entirely disappeared. Nieuport is now in ashes and ruins. When I passed the day there in the summer of 1910, it was a sleepy, quiet spot, a small fishing village, with old men and women sitting in doorways and on the waysides, mending nets, and knitting heavy woolen socks or sweaters of dark blue. In the small harbor were the black hulls of fishing boats tied up to the quaysides, and a small steamer from Ghoole was taking on a cargo of potatoes and beets. Some barges laden with wood were being pulled through the locks by men harnessed to a long tow rope, and a savage dog on one of these barges menaced me with dripping fangs and bloodshot eyes when I stopped to talk to the steersman, who sat on the tiller smoking a short, evil-smelling pipe, while his " vrouwe " was hanging out a heavy wash of vari-colored garments

100

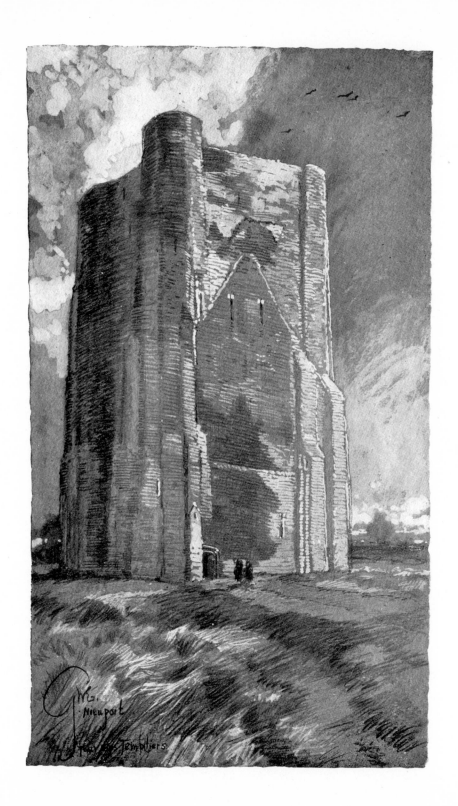

Nieuport

Tour des Templiers

on a line from the staff on the bow to a sweep fastened upright to the cabin wall.

The ancient fortification had long since disappeared — those "impregnable walls of stone" which once defended the town from the assaults of Philip the Second. I found with some difficulty a few grass-grown mounds where they had been, and only the gray, grim tower of the Templars, standing solitary in a turnip field, remained to show what had been a mighty stronghold. In the town, however, were souvenirs enough to occupy an antiquary for years to his content and profit. There was the Cloth Hall, with its five pointed low arched doorways from which passed in and out the Knights of the Temple gathered for the first pilgrimage to the Holy Land. On this market square too was the great Gothic Church, one of the largest and most important in all Flanders, and on this afternoon in the summer of 1910, I attended a service here, while in the tower a bell ringer played the chime of famous bells which now lie in broken fragments amid the ashes of the fallen tower.

Here was fought the bloody "Battle of the Dunes," between the Dutch and the Spaniards in those dim days of long ago, when the stubborn determination of the Netherlanders overcame the might and fiery valor of the Spanish invaders.

From time to time the peasants laboring in the fields un-

covered bones, broken steel breast-plates, and weapons, which they brought to the museum on the Grand' Place, and which the sleepy *custode* showed me with reluctance, until I offered him a franc. It is curious that famous Nieuport, for which so much blood was shed in those early days, should again have been a famous battle ground between the handful of valiant soldiers of the heroic King Albert and a mighty Teutonic foe.

The dim gray town with its silent streets, the one time home of romance and chivalry, the scene of deeds of knightly valor, is now done for forever. It is not likely that it can ever again be of importance, for its harbor is well-nigh closed by drifting sand. But I shall always keep the vision I had of it that summer day, in its market place, its gabled houses against the luminous sky, its winding streets, and narrow byways across which the roofs almost touch each other. The ancient palaces are now in ruins, and the peaceful population scattered abroad, charges upon the charity of the world. Certainly a woeful picture in contrast to the content of other days.

The vast green plains behind the dunes, or sand hills, extend unbrokenly from here to the French frontier, spire after spire dominating small towns, and wind-mills, are the objects seen. To some the flatness is most monotonous, but to those who find pleasure in the paintings of Cuyp, the country is very picturesque. The almost end-

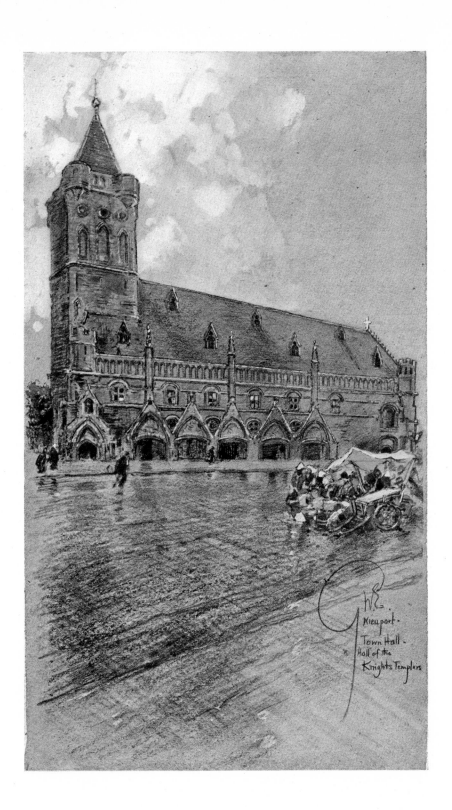

Nieuport.
Town Hall.
Hall of the
Knights Templars

less succession of green, well-cultivated fields and farmsteads is most entertaining, and the many canals winding their silvery ways through the country, between rows of pollards; the well kept though small country houses embowered in woody enclosures; the fruitful orchards in splendid cultivation; the gardens filled with fair flowers and the "most compact little towns"—these give the region a romance and attraction all its own.

Here and there is a hoary church erected in forgotten times on ground dedicated to Thor or Wodin. This part of the country bordering the fifty mile stretch of coast line on the North Sea was given over latterly to the populous bathing establishments and their new communities, but the other localities, such as Tournai, Courtrai, Oudenaarde or Alost, were seldom visited by strangers, whose advent created almost as much excitement as it would in Timbuctoo. It was not inaccessible, but the roads were not good for automobiles; they were mainly paved with rough "Belgian" blocks of stone, high in the center, with a dirt roadway on either side, used by the peasants and quite rutty.

A walking tour for any but the hardiest pedestrian was out of the question, so I was told that the best way for a "bachelor" traveler was to secure transportation on the canal boats. This was the warning that our kind hearted landlord in Antwerp gave us, after vainly endeavor-

ing to discourage us from leaving him for such a tour.

The canals, however, are not numerous enough in this region, I found, and besides there are various other disadvantages which I leave to the reader's imagination.

In addition to the main lines of the State Railway, there were what are called "Chemins-de-fer-vicinaux," small narrow gauge railways which traversed Belgium in all directions. On these the fares were very reasonable, and they formed an ideal way in which to study the country and the people. There were first, second and third class carriages on these, hung high on tall wheels, which looked very unsafe, but were not really so. The classes varied only in the trimming of the windows, and quality of the cushions on the benches. Rarely if ever, were those marked "I Klasse" used. Those of the second class were used sometimes; but the third class cars were generally very crowded with peasantry, who while invariably good humored and civil were certainly evil smelling, and intolerant of open windows and fresh air. The men and boys generally smoked a particularly vile-smelling black tobacco, of which they seemed very fond, and although some of the cars were marked "Niet rooken" (no smoking) no one seemed to object to the fumes.

Here one seldom saw the purely Spanish type of face so usual in Antwerp and Brabant. The race seemed

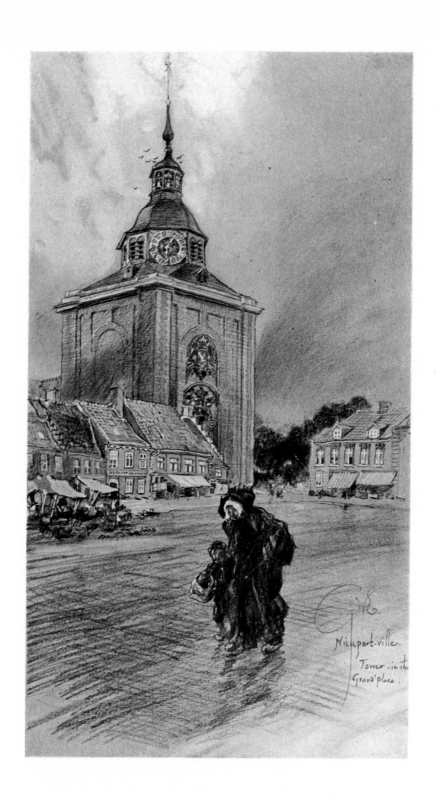

Nieuport-ville.
Tower - in the
Grand'place.

purer, and the peasants used the pure Flemish tongue. Few of the elders I found spoke French fluently, although the children used it freely to each other, of course understanding and speaking Flemish also.

There were various newspapers published in the Flemish language exclusively. These, however, were very primitive, given over entirely to purely local brevities, and the prices of potatoes, beets and other commodities, and containing also a " feuilleton " of interest to the farmers and laborers.

There were several " organs " of the Flemish Patriotic party devoted to the conservation and preservation of the Flemish language and the ancient traditions, which were powerful among the people, although their circulation could not have been very profitable. The peasantry in truth were very ignorant, and knew of very little beyond their own parishes. The educational standard of the people of West Flanders was certainly low, and it was a matter of comment among the opponents of the established church, that education being in the hands of the clergy, they invariably defeated plans for making it compulsory. But nevertheless, the peasantry were to all appearances both contented and fairly happy.

As their wants were few and primitive, their living was cheap. Their fare was coffee, of which they consumed a great deal, black bread, salt pork and potatoes. The use

of oleomargarine was universal in place of butter. They
grew tobacco in their small gardens for their own use,
and also, it is whispered, smuggled it [and gin] over the
border into France. They worked hard and long from
five in the morning until seven or eight in the evening.

The Flemish farmhouse was generally well built, if
somewhat untidy looking, with the pigstys and out build-
ings in rather too close proximity for comfort. There
was usually a large living room with heavy sooty beams
overhead, and thick walls pierced by quaint deeply
sunken windows furnished often with seats. These pic-
turesque rooms often contained " good finds " of the old
Spanish furniture, and brass; but as a rule the dealers had
long since bought up all the old things, replacing them by
" brummagem,"— modern articles shining with cheap
varnish.

The peasants themselves in their everyday clothes cer-
tainly did not impress the observer greatly. They were
not picturesque, they wore the sabôt or " Klompen," yel-
low varnished, and clumsy in shape. Their stockings
were coarse gray worsted. Their short trousers were us-
ually tied with a string above the calf, and they wore a
sort of smock, sometimes of linen unbleached, or of a shin-
ing sort of dark purple thin stuff.

The usual headgear was for the men a cap with a glazed
peak and for the women and girls a wide flapped em-

broidered linen cap, but this headgear was worn only in
the country towns and villages. Elsewhere the costume
was fast disappearing. On Sundays when dressed in
their holiday clothes these peasants going to or returning
from mass, looked respectable and fairly prosperous, and
it was certainly clear that although poor in worldly goods,
these animated and laughing throngs were far from being
unhappy or dissatisfied with life as they found it in West
Flanders.

Alost

Alost

THE ancient Hotel de Ville on the Grand' Place
was unique, not for its great beauty, for it had
none, but for its quaintness, in the singular com-
bination of several styles of architecture. Without go-
ing into any details its attraction was in what might be
called its venerable coquettishness,— bizarre, one might
have styled it, but that the word conveys some hint of
lack of dignity. One is at a loss just how to characterize
its attractiveness. Against the sky its towers and min-
arets held one's fancy by their very lightness and airi-
ness, the lanterns and *fleches* presupposing a like grace
and proportion in the edifice below. The great square
belfry at one side seemed to shoulder aside the structure
with its beautiful Renaissance façade and portal and
quite dominate it.

My note book says that it dated from the fifteenth
century, and its appearance certainly bore evidence of
this statement. It had been erected in sections at various
periods, and these periods were marked in the various
courses of brick, showing every variety of tone of dull

reds, buffs, and mellow purplish browns. The effect was quite delightful. The tower contained a fine carillon of bells arranged on a rather bizarre platform, giving a most quaint effect to the turret which surmounted it. The face of the tower bore four niches, two at each side of the center and upper windows, and these contained time worn statues of the noble counts of Alost. On the wall below was a tablet bearing the inscription "Ni Espoir, Ni Craint," and this I was told referred either to the many sieges which the town suffered, or a pestilence which depopulated the whole region. A huge gilt clock face shone below the upper gallery, at each corner of which sprang a stone gargoyle.

The old square upon which this tower was placed was quite in keeping with it. There were rows of gabled stone houses of great antiquity, still inhabited, stretching away in an array of façades, gables, and most fantastic roofs, all of mellow toned tile, brick and stone.

Thierry Moertens, who was a renowned master printer of the Netherlands, was born here, and is said to have established in Alost the "very first printing house in Flanders." From this press issued a translation of the Holy Bible, which was preserved in the Museum of Brussels, together with other fine specimens of his skill. A very good statue in bronze to this master printer was in the center of the market place, and on the occasion of my

The Town Hall: Alost

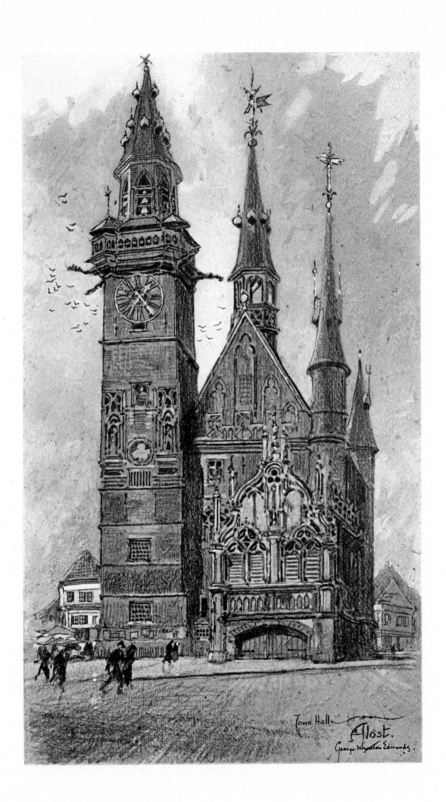

Town Hall.
Alost.
George Wharton Edwards.

last visit, there was a sort of carnival in the town, with a great gathering of farmers and merchants and their families from the surrounding country all gathered about the square, which was filled with wagons, horses, booths, and merry-go-rounds, above which the statue of the old master printer appeared in great dignity. There was a great consumption of beer and waffles at the small *estaminets*, and the chimes in the belfry played popular songs at intervals to the delight of these simple happy people, all unaware of the great catastrophe of the war into which they were about to be plunged.

A disastrous conflagration destroyed most of Alost in 1360, and thereafter history deals with the fury of the religious wars conducted by the Spanish against Alost, a most strongly fortified town. The story of the uniting of these Spanish troops under the leadership of Juan de Navarese is well known. Burning and sacking and murder were the sad lot of Alost and its unfortunate citizens, who had hardly recovered, ere the Duke d'Alençon arrived before the walls with his troops, bent upon mischief. The few people remaining after his onslaught died like flies during the plague which broke out the following year, and the town bid fair to vanish forever.

Rubens painted a large and important picture based upon the destruction of Alost, and this work was hanging in the old church of St. Martin just before the outbreak

of the war in 1914. Its fate is problematical, for St. Martin's Church was razed to the ground in the bombardment in 1914–15, the charge being the usual one that the tower was used for military purposes by the French.

This old church with its curious bulbous tower cap was at the end of a small street, and my last view of it was on the occasion of a church fête in which some dignitaries were present, for I saw them all clad in scarlet and purple walking beneath silken canopies attended by priests bearing lighted lanterns (although the sun was shining brightly at the time) and acolytes swinging fragrant smoking censers. We were directed to a rather shabby looking hostelry, over the door of which was an emblazoned coat of arms of Flanders, where we were assured we could get " déjeuner " before leaving the town.

As usual, a light drizzle came on, and the streets became deserted. The hotel was a wretched one and the meal furnished us was in character with it. We were waited on by a sour, taciturn old man who bore a dirty towel on his arm, as a sort of badge of office, I presume. He nodded or shook his head as the case might demand, but not a word could I extract from him. At the close of our meal, which we dallied over, waiting for the rain to cease, I called for the bill, which was produced after a long wait, and proved to be, as I anticipated, excessive. We had coffee and hot milk and some cold chicken and

salad. This repast, for two, came to twelve francs. And as the " chicken " had reached its old age long before, and the period of its roasting must have taken place at an uncertain date, this, together with the fact that the lettuce was wilted, placed these items upon the proscribed list for us. The coffee and hot milk, however, was good and, thus revived and rested, I paid the bill without protest, and having retained the carriage which we hired at the station, I bundled our belongings into it. I had resolved not to tip the surly old fellow, but a gleam in his eye made me hesitate. Then I weakened and gave him a franc.

To my amazement he said in excellent English: " I thank you, sir; you are a kind, good and patient man, and madam is a most charming and gracious lady. I am sorry your breakfast was so bad, but I can do nothing here; these people are impossible; but it is no fault of mine." And shaking his head he vanished into the doorway of the hotel. Driving away, I glanced up at the windows, where behind the curtains I thought I saw several faces watching us furtively. It might be that we had missed an adventure in coming away. Had I been alone I should have chanced it, for the old waiter interested me with his sudden confidence and his command of English. But whatever his story might have been, it must ever be to me a closed book. Quaint Alost among the trees is now a heap of blackened ruins.

Courtrai

Courtrai

THE two large and impressive stone towers flanking a bridge of three arches over the small sluggish river Lys were those of the celebrated Broël, dating from the fourteenth century. The towers were called respectively the "Speytorre" and the "Inghelbrugtorre." The first named on the south side of the river formed part of the ancient "enceinte" of the first château of Philip of Alsace, and was erected in the twelfth century, and famed with the château of Lille, as the most formidable strongholds of Flanders. The "Inghelbrugtorre" was erected in 1411–13, and strongly resembles its sister tower opposite. It was furnished with loopholes for both archers and for "arquebusiers," as well as openings for the discharge of cannon and the casting of molten pitch and lead upon the heads of besiegers after the fashion of warfare as conducted during the wars of the Middle Ages. The Breton soldiers under Charles the Eleventh attacked and almost razed this great stronghold in 1382.

A sleepy old *custode* whom we aroused took us down

into horrible dungeons, where, with a dripping tallow candle, he showed us some iron rings attached to the dripping walls below the surface of the river where prisoners of state were chained in former times, and told us that the walls here were three or four yards thick. The town was one of beauty and great charm, and here we stopped for a week in a most delightfully kept small hotel on the square, which was bordered with fine large trees, both linden and chestnut.

The town was famed in history for the Great Battle of the Spurs which took place outside the walls, in the year 1302, on the plains of Groveninghe. History mentions the fact that " seven hundred golden spurs were picked up afterwards on the battlefield and hung in the cathedral." These we were unable to locate.

The water of the Lys, flowing through the town and around the remains of the ancient walls, was put to practical use by the inhabitants in the preparation of flax, for which the town was renowned.

It ranked with the old city of Bruges in importance up to 1914, when it had some thirty-five thousand inhabitants. In the middle of the beflowered Grand' Place stood a quaint brick belfry containing a good chime of bells, and on market days when surrounded with the farmers' green wagons and the lines of booths about which the people gathered chaffering, its appearance was

The Belfry: Courtrai

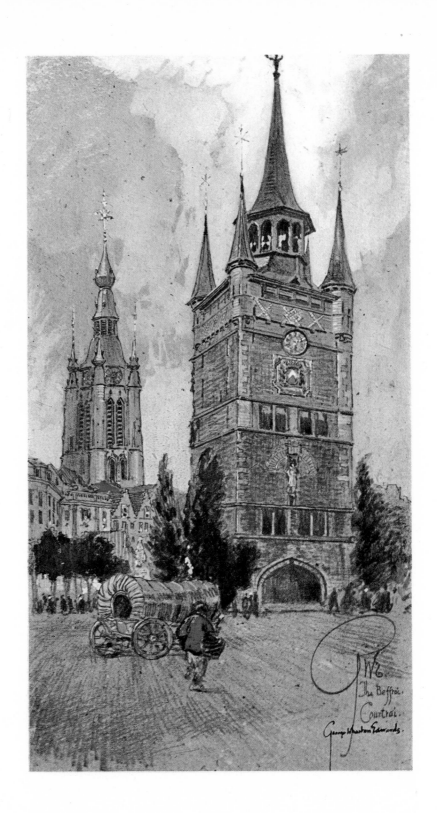

The Beffroi.
Courtrai.

George Wharton Edwards

picturesque enough to satisfy anyone, even the most blasé of travelers. The belfry had four large gilt clock faces, and its bells could be plainly seen through the windows hanging from the huge beams. On the tower were gilded escutcheons, and a couple of armor-clad statues in niches. There was a fine church dedicated to Notre Dame, which was commenced by Baldwin in 1199, and a very beautiful " Counts Chapel " with rows of statues of counts and countesses of Flanders whose very names were forgotten.

Here was one of the few remaining " Beguinages " of Flanders, which we might have overlooked but for the kindness of a passerby who, seeing that we were strangers, pointed out the doorway to us.

On either hand were small houses through the windows of which one could see old women sitting bowed over cushions rapidly moving the bobbins over the lace patterns. A heavy black door gave access to the Beguinage, a tiny retreat, *Noyé de Silence*, inaugurated, tradition says, in 1238, by Jean de Constantinople, who gave it as a refuge for the Sisters of St. Bogga. And here about a small grass grown square in which was a statue of the saint, dwelt a number of self-sacrificing women, bound by no vow, who had consecrated their lives to the care of the sick and needy.

We spent an hour in this calm and fragrant retreat, where there was no noise save the sweet tolling of the con-

vent bell, and the cooing of pigeons on the ridge pole of the chapel.

In the square before the small station was a statue, which after questioning a number of people without result, I at length found to be that of Jean Palfyn who, my informant assured me, was the inventor of the forceps, and expressed surprise that I should be so interested in statuary as to care "who it was." He asked me if I was not English and when I answered that I was an American, looked somewhat dazed, much as if I had said "New Zealander" or "Kamschatkan," and was about to ask me some further question, but upon consideration thought better of it, and turned away shrugging his shoulders.

To show how well the river Lys is loved by the people, I quote here a sort of prose poem by a local poet, one Adolph Verriest. It is called "Het Leielied."

"La Lys flows over the level fields of our beautiful country, its fecund waters reflecting the blue of our wondrous Flemish landscape. Active and diligent servant, it seems to work ever to our advantage, multiplying in its charming sinuosities its power for contributing to our prosperity, accomplishing our tasks, and granting our needs. It gives to our lives ammunition and power. The noise of busy mills and the movement of bodies of workmen in its banks is sweet music in our ears, in tune to the rippling of its waters.

122

COURTRAI

" A silver ribbon starred with the blue corn-flower, the supple textile baptised in its soft waters is transformed by the hand of man into cloudy lace, into snowy linen, into fabrics of filmy lightness for my lady's wear, **La Lys**, name significant and fraught with poetry for us — giving life to the germ of the flax which it conserves through all its life better than any art of the chemist in the secret chambers of his laboratory.

" Thanks to this gracious river, our lovely town excels in napery and is known throughout all the world. In harvest time the banks of the Lys are thronged with movement, the harvesters in quaint costumes, their bodies moving rhythmically to the words of the songs they sing, swinging the heavy bundles of flax from the banks to the level platforms, where it is allowed to sleep in the water, and later the heavy wagons are loaded to the cadence of other songs appropriate to the work. Large picturesque colored windmills wave their brown velvety hued sails against the piled up masses of cloud, and over all is intense color, life and movement.

" The river plays then a most important part in the life on the Flemish plains about Courtrai, giving their daily bread to the peasants, and lending poetry to their existence. So, O Lys, our beautiful benefactor, we love you."

At this writing (March, 1916) Courtrai is still occu-

pied by the troops of the German Kaiser, and with the exception of the destruction of the Broël towers, the church of St. Martin, and the Old Belfry in the market place, the town is said to be "intact."

Whenever possible we traveled through the Flemish littoral on the small steam trams, "chemins-de-fer-vicinaux," as they are called in French, in the Flemish tongue "Stoomtram," passing through fertile green meadows dotted with fat, sleek, black and white cows, and embossed with shining silvery waterways connecting the towns and villages. We noticed Englishy cottages of white stucco and red tiled roofs, amid well kept fields and market gardens in which both men and women seemed to toil from dawn to dewy evening. Flanders before the war was simply covered with these light railways. The little trains of black carriages drawn by puffing covered motors, discharging heavy black clouds of evil-smelling smoke and oily soot, rushed over the country from morning until night, and the clanging of the motorman's bell seemed never ending.

To see the country thus was a privilege, and was most interesting, for one had to wait in the squares of the small towns, or at other central places until the corresponding motor arrived before the journey could proceed. Here there was a sort of exchange established where the farmers

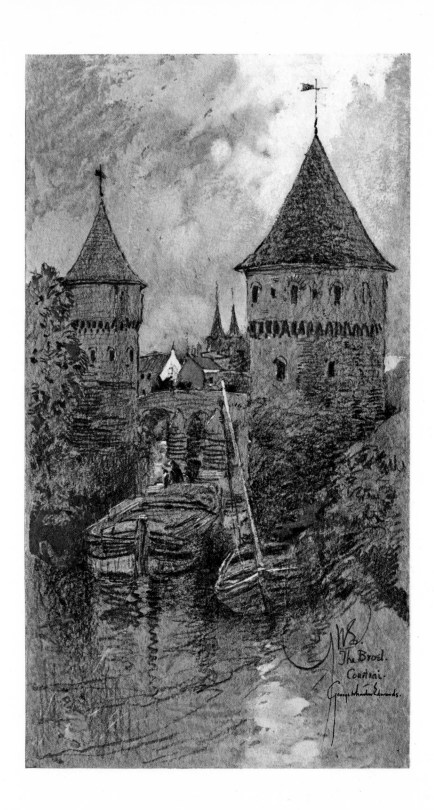

The Broel.
Courtrai.
George Wharton Edwards.

compared notes as to the rise or fall in commodities, or perchance the duty upon beets and potatoes.

Loud and vehement was the talk upon these matters; really, did one not know the language, one might have fancied that a riot was imminent.

One morning we halted at a small village called Gheluwe, where the train stopped beside a whitewashed wall, and everyone got out, as the custom is. There seemed no reason for stopping here, for we were at some distance from the village, the spire of which could be seen above a belt of heavy trees ahead. The morning was somewhat chilly, and the only other occupant of the compartment was a young cleric with a soiled white necktie. He puffed away comfortably at a very thin, long, and evil-smelling "stogie" which he seemed to enjoy immensely, and which in the Flemish manner he seemed to eat as he smoked, eyeing us the while amicably though absent mindedly, as if we were far removed from his vicinity. As we neared the stopping place, two very jolly young farmer boys raced with the train in their quaint barrow-like wagon painted a bright green, and drawn by a pair of large dogs who foamed and panted past us "ventre à terre," with red jaws and flopping tongues.

Had we not known of this breed of dogs we might have fancied, as many strangers do, that Flemish dogs are

badly treated, but this is not the case. These dogs are very valuable, worth sometimes as much as five hundred francs (about $100).

Inspections of these dogs are held regularly by the authorities. The straps and the arrangement of the girths are tested lest they should chafe the animal, and, I am told, the law now requires that a piece of carpet be carried for the animal to lie upon when resting, and a drinking bowl also has been added to the equipment of each cart. The dogs do not suffer. They are bred for the cart, and are called "*chiens de traite*," so that the charge of cruelty upon the part of ignorant tourists may be dismissed as untrue. There is a society for the prevention of cruelty to animals, and it is not unusual to see its sign displayed in the market places, with the caution "*Traitez les animaux avec douceur*." Rarely if ever is a case brought into court by the watchful police.

The young cleric gazed at us inquiringly, as if he expected to hear us exclaim about the cruelty to animals, but catching his eye I smiled, and said something about "*ces bons chiens*," at which he seemed relieved, and nodded back grinning, but he did not remove the stogie from his mouth.

Priests in Flanders seemed to enjoy much liberty of action, and do things not possible elsewhere. For instance, at Blankenberghe, a fashionable watering place on

the coast, I saw a prosperous, well-fed one (if I may so characterize him without meaning any offense) dining at the Great Gasthof on the digue, who after finishing his *filet aux champignons*, with a bottle of *Baune superior*, ordered his *" demi tasse "* with *fine champagne*, and an Havana cigar which cost him not less than three francs (sixty cents) which he smoked like a connoisseur while he listened to the fine military band playing in the Kiosk. And why not, if you please?

We remained for nearly twenty minutes beside this white wall at the roadside, the animated discussions of the farmers continuing, for the group was constantly augmented by fresh arrivals who meant to travel with us or back to the town from which we had come. It was here that we saw the first stork in Flanders, where indeed they are uncommon. This one had a nest in a large tree nearby. One of the boys shied a small stone at him as he flapped overhead, but, I think, without any idea of hitting him. The peasants assembled here eyed us narrowly. They probed me and my belongings with eyes of corkscrew penetration, but since this country of theirs was a show place to me, I argued that I had no right to object to their making in return a show of me. But such scrutiny is not comfortable, especially if one is seated in a narrow compartment, and the open-mouthed *vis à vis* gazes at one with steely bluish green unwinking eyes — some-

what red rimmed. Especially if such scrutiny is accompanied by free comments upon one's person, delivered in a voice so pitched as to convey the information to all the other occupants, and mayhap the engine driver ahead.

The other train at length arrived, there was an interchange of occupants and then we proceeded amid heavy clouds of thick black smoke which, for a time, the wind blew with us. Across the tilled fields are narrow paths leading to dykes and roads. There are many green ditches filled with water and in them we could see rather heavy splashes from time to time. These we discovered were made by large green bull frogs — really monsters they were, too. Of course we were below the sea level here, but one cannot credit the old story about the boy who plugged the dyke with his thumb, thereby saving the whole country.

The dykes are many feet high and as the foundation is composed of heavy black stones, then layers of great red bricks and tiles, and finally turf and large willow branches interlaced most cunningly like giant basket work, such a story is impossible.

My *vis à vis*, all the while regarding me unwinkingly, overheard me speak to A——, in English.

Then he slowly took the stogie from his mouth and ejaculated, " *Ach — Engelsch! — Do it well met you?* "

I replied that it certainly did.

COURTRAI

"*And met Madame?*"

I nodded.

"*Alst' u blieft mynheer — sir,*" he said. Then he changed his seat and thereafter related to the others that he had conversed with the strangers, who were English, and were traveling for pleasure, being *enormously rich.* I think thereafter he enjoyed the reputation of being an accomplished linguist. So, pleasantly did we amble along the narrow little steam tramway through luxurious green fields and smiling fertile landscape of the Flemish littoral in our well rewarded search for the quaint and the unusual.

The Gothic Town Hall, a remarkable construction on the Grand' Place, and erected 1526, has been restored with a great amount of good taste in recent years, and the statues on its façade have been replaced with such skill that one is not conscious of modern work.

The great Hall of the Magistrates on the ground floor, with its magnificent furniture, and the admirable modern mural paintings by the Flemish artists Guffens and Severts (1875) was worth a journey to see. The most noteworthy of these paintings represented the "Departure of Baldwin IX," Count of Flanders, at the beginning of the Fourth Crusade in 1202, and the "Consultation of the Flemish, before the great Battle of the Spurs" in 1302.

VANISHED TOWERS OF FLANDERS

In this chamber is a remarkable Renaissance mantelpiece, which is embellished with the arms of the Allied Towns of Bruges and Ghent, between which are the standard bearers of the doughty Knights of Courtrai, and two statues of the Archduke Albert and his Lady, all surrounding a statue of the Holy Virgin.

On the upper floor is the Council Chamber, in which is another mantelpiece hardly less ornate and interesting, and executed in what may be called the " flamboyant " manner in rich polychrome. It is dated 1527 and was designed by (one of the) Keldermans (?).

It has rows or ranges of statuary said to represent both the Vices and the Virtues. Below are reliefs indicating the terrible punishment inflicted upon those who transgress. Statues of Charles V, the Infanta Isabella, and others are on *corbels*.

Very large drawn maps of the ancient town and its dependencies cover the walls, and these are dated 1641.*

* Those who are interested in the subject are referred to C. Lemonnier's " Histoire des Beaux Arts en Belgique " (Brussels, 1881), E. Hessling's " La Sculpture Belge Contemporaire " (Berlin, 1903), Destree's " Renaissance of Sculpture in Belgium," Crowe and Cavalcaselle's " Early Flemish Painters " (1857).

Termonde (Dendermonde)

Termonde (Dendermonde)

A STRANGE half deserted little town on the right bank of the river Scheldt, clustered about a bridge, on both sides of a small sluggish stream called the "Dendre," where long lines of women were washing clothes the live-long day, and chattering like magpies the while. A Grand' Place, with heavy trees at one side, and on the other many small *estaminets* and drinking shops. That was Termonde. My note book says "Population 10,000, town fortified; forbidden to make sketches outside the walls, which are fortifications. Two good pictures in old church of Notre Dame, by Van Dyck, 'Crucifixion' and an 'Adoration of the Shepherds' (1635). Fine Hotel de Ville, with five gables and sculptured decoration. Also belfry of the fourteenth century."

Termonde is famed throughout Flanders as the birthplace of the "Four sons of Aymon," and the exploits of the great horse Bayard. The legend of the Four Sons of Aymon is endeared to the people, and they never tire of relating the story in song as well as prose. Indeed

this legend is perhaps the best preserved of all throughout Flanders. It dates from the time of Charlemagne, the chief of the great leaders of Western Europe, whose difficulty in governing and keeping in subjection and order his warlike and turbulent underlords and vassals is a matter of history known to almost every schoolboy.

Among these vassal lordlings, whose continued raids and grinding exactions caused him most anxious moments, was a certain Duke (Herzog) called Aymon, who had four sons, named Renault, Allard, Guichard, and Ricard, all of most enormous stature and prodigious strength. Of these Renault was the tallest, the strongest, the most agile, and the most cunning. In height he measured what would correspond to sixteen feet, " and he could span a man's waist with his hand, and lifting him in the air, squeeze him to death." This was one of his favorite tricks with the enemy in battle.

Aymon had a brother named Buves who dwelt in Aigremont, which is near Huy, and one may still see there the castle of Aymon, who was also called the Wild Boar of the Ardennes. This brother Buves in a fit of anger against Charlemagne for some fancied slight, sent an insulting message to the latter, refusing his command to accompany him on his expedition against the Saracens, which so exasperated Charlemagne that he sent one of his sons to remonstrate with Buves and if need be, to

threaten him with vengeance, in case he persisted in refusing. Buves was ready, and without waiting to receive his message, he met the messenger half way and promptly murdered him.

Then Charlemagne, in a fury, sent a large and powerful body of men to punish Buves, who was killed in the battle which took place at Aigremont. Thereupon the four sons of Aymon met and over their swords swore vengeance against Charlemagne, and betook themselves to the fastnesses of the Ardennes, in which they built for themselves the great Castle of Montfort which is said to have been even stronger than that called Aigremont.

On the banks of the river Ourthe may still be seen the great gray bulk of its ruins. About this stronghold they constructed high walls, and there they sent out challenges defying the great Emperor.

Now each of the four sons had his own fashion of fighting. Renault fought best on horseback, and to him Maugis son of Buves brought a great horse named Bayard ("Beiaard" in Flemish) of magic origin, possessed of demoniac powers, among which was the ability to run like the wind and never grow weary. Here in this stronghold the four sons of Aymon dwelt, making occasional sallies against the vassals of Charlemagne, until at length the Emperor gathered a mighty force of soldiers and horses and engines and scaling ladders, and, surrounding

the stronghold, at length succeeded in capturing it.

Tradition says that among Charlemagne's retinue was Aymon himself, and intimates that it was by the father's treachery that the four mighty sons were almost captured, but at any rate the great castle of Montfort was reduced to ashes and ruin, and only the fact of Renault's taking the other brothers on the back of the wondrous horse Bayard saved them all from the Emperor's fury. So they escaped into Gascony, where they independently attacked the Saracens and drove them forth and extended their swords to the King of Gascony, Yon, who treacherously delivered them in chains over to Charlemagne. These chains they broke and threw in the Emperor's face, fighting their way to freedom with their bare hands.

History thereafter is silent as to their end. Of Renault it is known only that he became a friar at Cologne, where his skill and strength were utilized by the authorities in building the walls, and that one day while at work, some masons whom he had offended crept up behind him and pushed him off a great height into the River Rhine, and thus he was drowned. Years afterward the Church canonized him, and in Westphalia at Dortmund may be seen a monument erected in his memory extolling his prowess, his deeds, and his strength.

As to the great and magical horse Bayard, the chronicle says that, captured finally by Charlemagne's soldiers and

brought before him, the Emperor deliberated what he should do with it, since it refused to be ridden. Finally he ordered that the largest mill stone in the region should be made fast to its neck by heavy chains, and that it should then be cast into the River Meuse.

Bayard contemptuously shook off the heavy stone and with steam pouring from his nostrils, gave three neighs of derision and triumph and, climbing the opposite bank, vanished into the gloom of the forest where none dared follow. Of the immortality of this great horse history is emphatic and gravely states that, for all that is known to the contrary, he may still be at large in the Ardennes, but that "no man has since beheld him."

And now yearly on the Grand' Place at Termonde there is a great festival and procession in his honor, depicting the chief incidents of his life and mighty deeds, while, at Dinaut, on the River Meuse, the scene of some of his mightiest deeds, may still be seen the great Rock Bayard, standing more than forty yards high and separated from the face of the mountain by a roadway cut by Louis the Sixteenth, who cared little for legends. From the summit of this great needle of rock sprang the horse Bayard, flying before the forces of Charlemagne with the four brothers on his back, and, so tradition says, "leaped across the river, disappearing in the woods on the further bank."

VANISHED TOWERS OF FLANDERS

We were fortunate in being at Termonde on the occasion of this picturesque festival. Songs of Bayard and his prowess were sung in the streets by various musical societies, each of which carried huge banners bearing their titles and honors, and some curious frameworks on poles which were literally covered with medals and wreaths bestowed upon the societies by the town at various times. These were borne proudly through the streets, and each society had its crowd of partisans and loud admirers. Had it not been so picturesque and strange, it would have seemed childish and pathetic, but the people were so evidently in earnest and seemed to enjoy it so hugely that the chance stranger could not but enter into the spirit of it all with them. This we did and wisely. There was much drinking of a thin sour beer called " faro," which is very popular with the peasants, and the various societies sang themselves hoarse, to the delight of all, including themselves. The horse Bayard, as seen in the market place, was a great wicker affair hung in wondrous chain armor, and the four sons of Aymon, also of wickerwork, and likewise clad in armor, each bearing a huge sword, sat upon his back and were trundled through the streets. There were also booths in which the inevitable and odoriferous fritters were fried, and some merry-go-rounds with thunderous, wheezy, groaning steam organs splitting one's ears, and platforms upon which the peasants danced

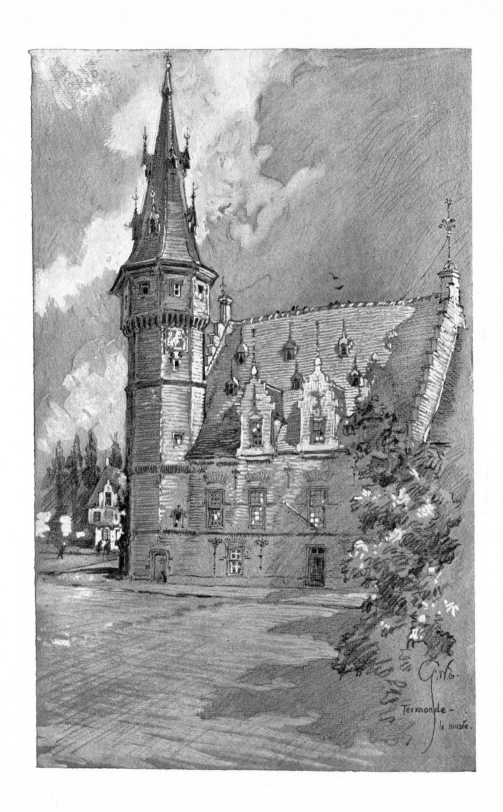

Termonde —
le musée.

and danced until one would have thought them fit to drop with fatigue.

It did not take long to examine the attractions most thoroughly, but there were two very extraordinary exhibits of enormously fat women (who are great favorites with the peasantry, and no celebration seems to be complete without them). Their booths were placed opposite to each other, nearly face to face, with only about forty feet between them. In this space crowded the peasants listening open mouthed in wonder at the vocabulary of the rival " barkers."

As usual, a shower came on during the afternoon, and the decorations were soaked with the downpour. The wickerwork horse Bayard was left to itself out in the square, and the wind whisked the water soaked draperies over its head, disclosing piteously all of its poor framework. The leaden skies showing no promise of clearing, we called the driver of the ancient " fiacre," and after settling our score at the " Grande Hôtel Café Royal de la Tête d'Or," we departed for the station of the " chemin de fer," which bumped us well but safely along the road to Antwerp.

We came again later on to this little town on the river, thinking that we might not have done it entire justice, because of the discomfort of the rainy day. And while we did not, it is true, find anything of great value to re-

cord, nor anything in the way of bells to gloat over, still our rather dismal impression of the little town in the drizzling rain as we last saw it, was quite removed and replaced by a picture more to our liking.

We were constantly finding new and unusual charms in the quaint old towns, each seeming for some reason quainter than the preceding one. Here on this occasion it looked so tranquil, so somnolent, that we tarried all unwilling to lose its flavor of the unusual. There were old weather beaten walls of ancient brick, mossy in places, and here and there little flights of steep steps leading down into the water; broad pathways there were too, shaded by tall trees and behind them vistas of delightful old houses, each doubtless with its tales of joy, gayety, pain or terror of the long ago.

The local policeman stood at a deserted street corner examining us curiously. He was the only sign of life visible except ourselves, and soon he, satisfied that we were only crazy foreigners with nothing else to do but wander about, took himself off yawning, his hands clasped behind his back, and his short sword rattling audibly in the stillness.

The atmosphere of this silent street by the river, shaded almost to a twilight by the thick foliage, with the old houses all about us, seemed to invite reminiscence, or dreams of the stern and respectable old burghers and

burgesses in sombre clothing, wide brimmed hats, and stiffly starched linen ruffs about their necks as rendered by Rembrandt, Hals, Rubens and Jordaens. They must have been veritable domestic despots, magnates of the household, but certainly there must have been something fine about them too, for they are most impressive in their portraits.

"They shook the foot of Spain from their necks," and when they were not fighting men they fought the waters. Truly the history of their struggles is a wondrous one! None of these was in sight, however, as we strolled the streets, but we did disturb the chat or gossip of two delightful, apple cheeked old ladies in white caps, who became dumb with astonishment at the sight of two foreigners who walked about gazing up at the roofs and windows of the houses, and at the mynheer in knickerbockers who was always looking about him and writing in a little book.

One cannot blame them for being so dumbfounded at such actions, such *incomprehensible* disturbing actions in a somnolent town of long ago. In the vestibule of the dark dim old church I copied the following inscription from a wall. It sounds something like English gone quite mad — and the last line, it seems to me, runs rather trippingly — and contains something of an idea too, whatever it means:

VANISHED TOWERS OF FLANDERS

" Al wat er is. Mijn hoop is Christus en zyn bloed.
" Door deze leer ik en hoop door die het eenwig goed.
" Ons leven is maar eenen dag, vol ziekten en vol naar geklag.
" Vol rampen dampen (!) en vendriet. Een schim
" Eien droom en anders niet."

A small steamer had advertised to leave for Antwerp about 3 o'clock. It lay puffing and wheezing at the side of the stream, and we went on board and settled ourselves comfortably, tired out with our wanderings. Here a bevy of children discovered us and ranged themselves along the dyke to watch our movements, exploding with laughter whenever we addressed one another. Finally an oily hand appeared at the hatchway of the engine room, followed by the touseled yellow head of a heavily bearded man. He looked at us searchingly, then at the line of tormenting children. Then he seized a long pole and advanced threateningly upon the phalanx. They fled incontinently out of reach, calling out various expletives in Flemish — of which I distinguished only one, " Koek bakker "! This would seem to be the crowning insult to cast at a respectable engineer, for he shook his fist at them.

To our amazement he then touched his greasy cap to us, and in the broadest possible Scotch dialect bade us welcome. There is a saying that one has only to knock on the companion ladder of any engine room in any port

142

the world over, and call out "Sandy" to bring up in response one or two canny Scots from the engine room below. This little steamer evidently took the place of the carrier's cart used elsewhere; for passengers and parcels, as well as crates of vegetables were her cargo. At length we started puffing along the river, and stopping from time to time at small landings leading to villages whose roofs appeared above the banks and dykes.

Delightful bits of the more intimate side of the people's life revealed themselves to us on these unusual trips. We passed a fine looking old peasant woman in a beautiful lace cap, rowing a boat with short powerful strokes in company with a young girl, both keeping perfect time. The boat was laden with green topped vegetables and brightly burnished brass milk cans, forming a picture that was most quaint to look upon. And later we passed a large Rhine barge, from the cabin of which came the most appetizing odor of broiled bacon. Our whistle brought out the whole family, and likewise a little nervous black and white dog who went nearly mad with the excitement attendant upon driving us away from the property he had to protect.

Night was falling when we reached the quay side in Antwerp, and we disembarked to the tinkling melody of the wondrous chimes from the tower of the great Cathedral.

Louvain

Louvain

T was in the great Gothic Church of St. Peter that Mathias Van den Gheyn delighted to execute those wonderful "*morceaux fugues*" now at once the delight and the despair of the musical world, upon the fine chime of bells in the tower. This venerable tower was entirely destroyed in the terrible bombardment of the town in 1914. It is probable that no town in Belgium was more frequented by learned men of all professions, since its university enjoyed such a high reputation the world over, and certainly its library, likewise entirely destroyed, with its precious tomes and manuscripts, was considered second to none.

The old Church of St. Peter, opposite the matchless Hôtel de Ville, was a cruciform structure of noble proportions and flanked with remarkable chapels; it was begun, according to the archives in Brussels, in 1423, to replace an earlier building of the tenth century, and was " finished " in the sixteenth century. There was, it seems, originally a wooden spire on the west side of the structure but " it was blown down in a storm in 1606."

VANISHED TOWERS OF FLANDERS

When I saw it in 1910, the church was in process of restoration, and the work was being very intelligently done by competent men. Before the façade was a most curious row of bizarre small houses of stucco, nearly every one of which was a sort of saloon or café, and the street before them was quite obstructed by small round tables and chairs at which, in the afternoon from four to five, the shopkeepers and bourgeois of the town gathered for the afternoon "*aperitif*," whatever it might be, and to discuss politics. For be it known that this period before the outbreak of the war, was in Belgium a troublous one for the Flemings, because of the continued friction between the clerical and the anti-clerical parties. These bizarre houses, I was told by one of the priests with whom I talked, were owned by the church, and were very profitable holdings, but tourists and others had made such sport of them, and even entered such grave protests to the Bishop, that the authorities finally concluded to tear them down. But they were certainly very picturesque, as my picture shows, their red tiled roofs and green blinds, making most agreeable notes of color against old St. Peter's gray wall.

The church so wantonly destroyed in 1914 contained some most remarkable works of art in the nine chapels. Among these were the "Martyrdom of St. Erasmus," by Dierick Bouts, long thought to be a work of Memling.

The Cathedral: Louvain

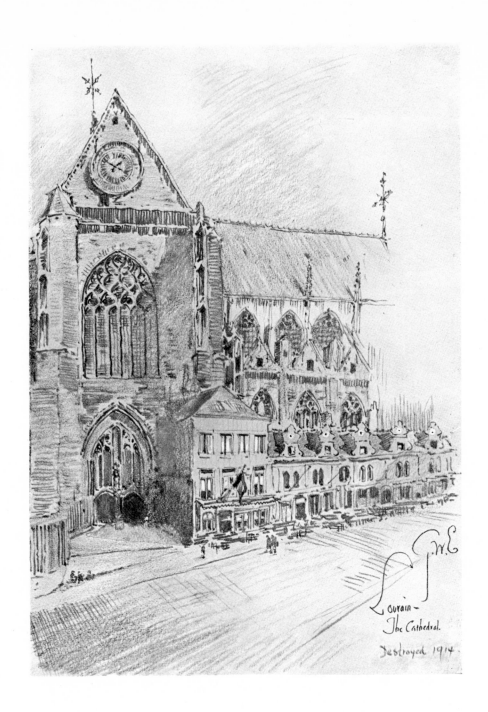

Louvain—
The Cathedral.
Destroyed 1914.

Another painting, " The Last Supper," was also considered one of Memling's works, until its authenticity was established by the finding of the receipt by Bouts for payment, discovered in the archives of the Library in Louvain in 1870. Formerly the church owned a great treasure in Quentin Matsys' "Holy Family," but this was sold to the Brussels Museum for something less than £10,000, and upon the outbreak of the war was in that collection. It is said that most of these great paintings owned in Belgium were placed in zinc and leaden cases and sent over to England for safety. It is to be hoped that this is true.

The *custode* showed, with most impressive manner, a quaint image of the Savior which, he related, was connected with a miraculous legend to the effect that the statue had captured and held a thief who had broken into the church upon one occasion! The townspeople venerate this image, and on each occasion when I visited the church, I noted the number of old women on their knees before it, and the many lighted waxen candles which they offered in its honor. A wave of indignation passed over the world of art when the newspapers reported the destruction of the beautiful Hôtel de Ville, just opposite old St. Peter's. This report was almost immediately followed by a denial from Berlin that it had suffered any harm whatever, and it would seem that this is true.

The Library, however, with its hundreds of thousands

of priceless records, and masterpieces of printing is, it is admitted, entirely destroyed! This great building, black and crumbling with age, was situated in a small street behind the Hôtel de Ville. The town itself was bright and clean looking, and there was a handsome boulevard leading from the new Gothic railway station situated in a beflowered parkway, which was lined with prosperous looking shops. This whole district was " put to the torch" and wantonly destroyed when the town was captured in 1914. Late photographs show the new station levelled to the ground, and the parkway turned into a cemetery with mounds and crosses showing where the soldiers who lost their lives in the bombardment, and subsequent sacking, are buried.

Remembering the complete destruction of Ypres, one can only believe that the preservation of the Hôtel de Ville was entirely miraculous and unintentional.

P. J. Verhaegan, a Flemish painter of considerable reputation and ability, had decorated one of the two " absidiole " chapels which contained a very richly carved tomb over a certain lady of the thirteenth century whose fame is known all over Flanders. The legend was most dramatically told to me by one of the young priests of St. Peter's, and this is the story of the beautiful Margaret, called " the Courageous," (La Fière).

By the Grace of God, there lived in Louvain, in the

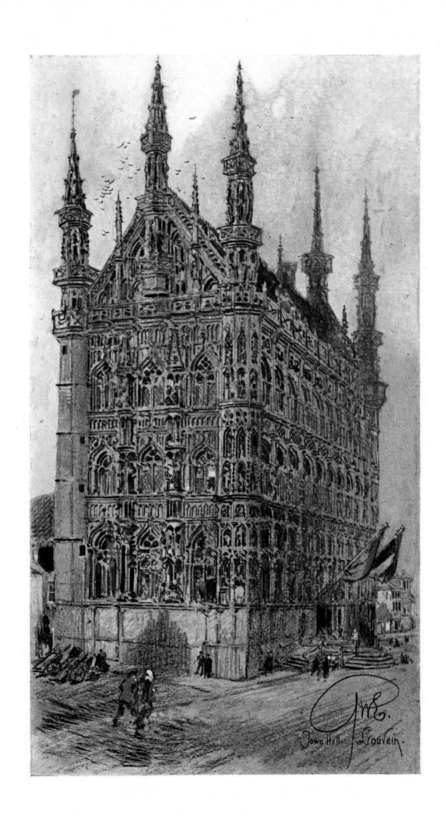

Town Hall. Louvain.

year 1235, one Armand and his wife, both devout Catholics and the keepers of a travelers' "ordinary" on the road to the coast, called Tirlemont. These two at length decided to retire from their occupation as "Hôteliers," and devote and consecrate the remainder of their lives to God, and the blessed saints.

Now they had a niece who was a most beautiful girl and whose name was Margaret, and she had such disdain for the young gallants of Louvain that they bestowed upon her the name of "La Fière." Although but eighteen years of age she determined to follow the example of her uncle and aunt, and later become a "Beguine," thus devoting her life to charity and the care of the sick and unfortunate, for this is the work of the order of "Beguines."

They realized a large sum of money from the sale of the hotel, and this became known throughout the country-side. It was said that the money was hidden in the house in which they lived, and at length eight young men of evil lives, pondering upon this, resolved that they would rob this noble couple. Upon a stormy night they demanded admittance, saying that they were belated travelers.

The young girl Margaret was absent from the room for a moment, when these ruffians seized the old couple and murdered them. On her return to the upper room from

the cellar, Margaret surprised them ransacking the strong box beside the fireplace. So they overpowered her also, but at once there ensued an argument as to what should be done with her, when the chief rogue, admiring her great beauty, proposed to her that she accept him as her lover and depart with him for France, where they could live happily. This she scornfully refused, whereupon " one of the ruffians strangled her for ten marcs of silver; and her soul, white and pure as the angels, ascended to the throne of Jesus, in whom she so well believed, and there became ' *l'unique espoux dont elle ambitionait l'Amour.*' "

It is said that Henry the First sitting in a window of his château on the river Dyle one night, saw floating on the dark water the corpse of this young martyr, where the ruffians had thus thrown her, and " the pale radiance from her brow illuminated the whole valley." Calling to his consort, Marguerite of Flanders, he pointed out to her the wondrous sight, and hastening forth they drew her dripping body from the dark slimy water and bore it tenderly to the château. The news spread far and wide, and for days came throngs to view the " sweet martyr's " body, for which the priests had prepared a costly catafalque, and for her a grand mass was celebrated in St. Peter's where she was laid at rest in a tomb, the like of which for costliness was never seen in Flanders.

LOUVAIN

And this is the legend of Margaret, called "La Fière," whose blameless life was known throughout the land.

I wish that I had made a drawing of this tomb while I was in the church, but I neglected unfortunately to do so. It was of simple lines, but of great richness of detail. Of course both it and the beautiful wax paintings of M. Verhaegan are now entirely destroyed in the ruins of St. Peter's.

Douai

Douai

ALTHOUGH across the border in France, Douai must still be called a Flemish town, because of its history and affiliations. The town is quaint in the extreme and of great antiquity, growing up originally around a Gallo-Roman fort. In the many wars carried on by the French against the English, the Flemish and the Germans, not to mention its sufferings from the invading Spaniards, it suffered many sieges and captures. Resisting the memorable attack of Louis the Eleventh, it has regularly celebrated the anniversary of this victory each year in a notable Fête or Kermesse, in which the effigies of the giant Gayant and his family, made of wickerwork and clad in medieval costumes, are paraded through the town by order of the authorities, followed by a procession of costumed attendants through the tortuous streets, to the music of bands and the chimes from the belfry of the Hôtel de Ville.

This, the most notable edifice in the town, is a fine Gothic tower one hundred and fifty feet high, with a remarkable construction of tower and turrets, supported

157

by corbels of the fifteenth century, containing a fine chime of bells made by the Van den Gheyns. The bells are visible from below, hanging sometimes well outside the turret of the bell chamber, and, ranging tier upon tier, from those seemingly the size of a gallon measure, to those immense ones weighing from fifteen hundred to two thousand pounds. This great tower witnessed the attack and occupation of the Spaniards, the foundation by the Roman Catholics of the great University in 1652 to counteract the Protestantism of the Netherlands, which had but a brief career, and the capture of the town by Louis the Fourteenth. Here was published in 1610 an English translation of the Old Testament for Roman Catholics, as well as the English Roman Catholic version of the scriptures, and the New Testament translated at Rheims in 1582, and known as the " Douai Bible." This was also the birthplace of Jean Bellgambe, the painter (1540) surnamed "Maître des Couleurs," whose nine great oaken panels form the wonderful altarpiece in the church of Notre Dame.

Douai was, before the great war, a peaceful industrial center of some importance, of some thirty thousand inhabitants. It has been said that the Fleming worked habitually fifty-two weeks in the year. An exception, however, must be made for fête days, when no self-respecting Fleming will work. On these days the holiday

The Town Hall: Douai

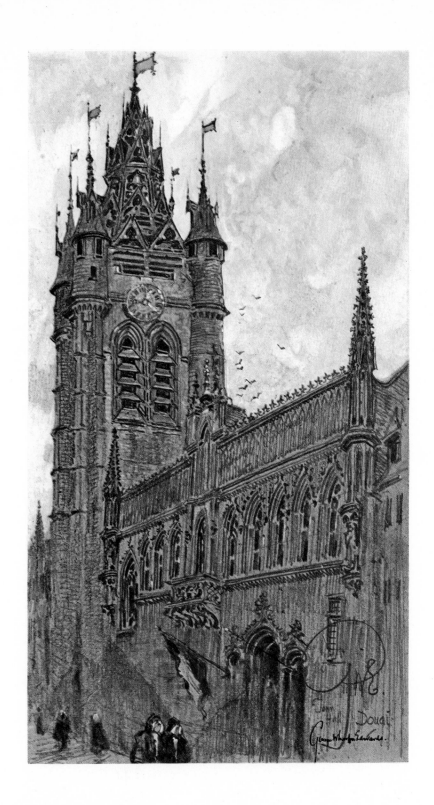

Town Hall Douai

George Wharton Edwards

makers are exceedingly boisterous, and the streets are filled with the peasants clad in all their holiday finery. But it is on the day of the Kermesse that your Fleming can be seen to the best advantage. There are merry-go-rounds, shooting galleries, swings, maybe a traveling circus or two, and a theatrical troupe which shows in a much bespangled and mirrored tent, decorated with tinsel and flaming at night with naphtha torches. Bands of music parade the streets, each carrying a sort of banneret hung with medals and trophies awarded by the town authorities at the various "*séances*."

But the greatest noise comes from the barrel organs of huge size and played by steam, or sometimes by a patient horse clad in gay apparel who trudges a sort of treadmill which furnishes the motive power. In even these small towns of Ancient Flanders such as Douai, the old allegorical representations, formerly the main feature of the event, are now quite rare, and therefore this event of the parade of the wicker effigies of the fabulous giant Gayant and his family was certainly worth the journey from Tournai. The day was made memorable also to the writer and his companion because of the following adventure.

There had been, it seems, considerable feeling against England among the lower orders in this border town over the Anglo-Boer War, so that overhearing us speaking

English, some half grown lads began shouting out at us "Verdamt Engelsch" and other pleasantries, and in a moment a crowd gathered about us.

With the best Flemish at his command the writer addressed them, explaining that we were Americans, but what the outcome would have been, had it not been for the timely arrival of a gendarme, I know not; but under his protection we certainly beat a hasty retreat. The lower classes of Flemings in their cups are unpleasant people to deal with, and it were well not to arouse them. But for this incident, and the fact that the afternoon brought on a downpour of rain, which somewhat dampened the ardor of the people and the success of the fête, our little trip over the border to this historic town would be considered worth while. Our last view of Douai was from the train window as we recrossed the river Scarpe, with the massive tower of the Hôtel de Ville showing silhouetted dim and gray against a streaming sky.

Oudenaarde

Oudenaarde

FROM the small stucco station, embowered in luxuriant trees, we crossed a wide grass grown square, faring towards the turrets of the town, which appeared above the small red and black tiled roofs of some mean looking peasant houses, and an *estaminet*, of stucco evidently brand new, and bearing a gilt lion over its door. Here a wide and rather well paved street led towards the town, bordered upon either hand by well kept and clean but blank looking houses, with the very narrowest sidewalks imaginable, all of which somehow reminded us of some of the smaller streets of Philadelphia. The windows of these houses flush with the street were closely hung with lace, and invariably in each one was either a vase or a pot of some sort filled with bright flowers. Occasionally there was a small poor looking shop window in which were dusty glass jars of candy, pipes, packages of tobacco, coils of rope and hardware, and in one, evidently that of an apothecary, a large carved and varnished black head of a grinning negro, this being the sign for such merchandise as tobacco and drugs.

Here and there doorways were embellished with shiny brass knockers of good form, and outside one shop was a tempting array of cool green earthenware bowls of such beautiful shape that I passed them by with great longing.

Soon this street made a turning, where there was a good bronze statue to some dignitary or other, and I caught a glimpse of that wondrous tower of the famous Hôtel de Ville, the mate to that at Louvain, and soon I was beneath its Gothic walls, bearing row upon row of niches, empty now, but once containing effigies of the powerful lords and ladies of Flanders. These rows rise tier upon tier to that exquisitely slender lacelike tower crowned with a large gilded statue of the town's patron, pennant in hand, and shining in the sunlight.

From the Inn of the " Golden Apple of Oudenaarde " just opposite, I appraised its beauties over a good meal of young broiled chicken and lettuce salad, and a bowl of " *café au lait*," that was all satisfying.

Afterwards, the *custode*, an old soldier, showed us the " Salle des Pas Perdus," containing a fine chimney piece alone worth the journey from Antwerp, and the Council Chamber, still hung with some good ancient stamped leather, and several large badly faded and cracked Spanish paintings of long forgotten dignitaries both male and female.

One Paul Van Schelden, a wood carver of great ability

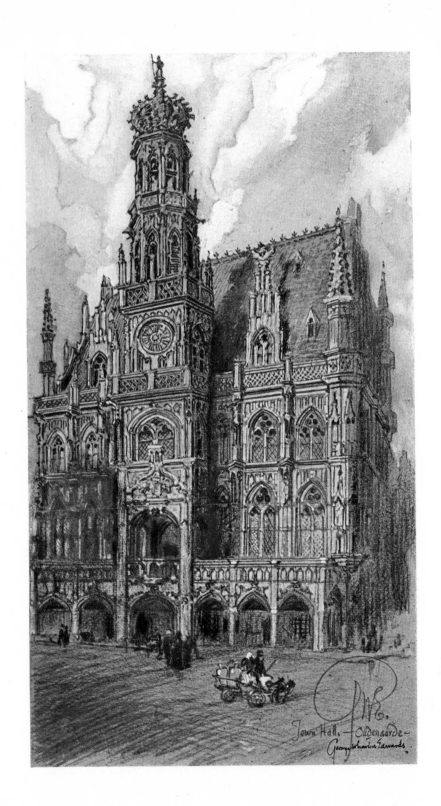

Town Hall — Oudenaarde —
George Wharton Edwards.

and renown, wrought a wonderful doorway, which was fast falling apart when I saw it. This gave access to a large room, the former Cloth Hall, now used as a sort of theatre and quite disfigured at one end by a stage and scenic arch. The walls were stenciled meanly with a large letter A surmounted by a crown. The interior had nothing of interest to show.

On the opposite side of the square was the large old church of St. Walburga, with a fine tower capped by a curious upturned bulbous cupola, upon which was a large gilt open-work clock face. As usual, there was a chime of bells visible, and a flock of rooks circling about the tower. The style of St. Walburga was Romanesque, with Gothic tendencies. Built in the twelfth century, it suffered severely at the hands of the Iconoclasts, and even in its unfinished state was very impressive, none the less, either, because of the rows of small stucco red roofed houses which clung to its walls, leaving only a narrow entrance to its portal. Inside I found an extremely rich polychromed Renaissance " reredos," and there was also the somewhat remarkable tomb of " Claude Talon," kept in good order and repair.

Oudenaarde was famed for the part it played in the history of Flanders, and was also the birthplace of Margaret of Parma. It was long the residence of Mary of Burgundy, and gave shelter to Charles the Fifth, who

sought the protection of its fortifications during the siege of Tournai in 1521.

Here, too, Marlborough vanquished the French in 1708. I might go on for a dozen more pages citing the names of remarkable personages who gave fame to the town, which now is simply wiped from the landscape. But by some miracle, it is stated, the Town Hall still stands practically uninjured. I have tried in vain to substantiate this, or at least to obtain some data concerning it, but up to this writing my letters to various officials remain unanswered.

I like to think of Oudenaarde as I last saw it — the huge black door of the church yawning like a gaping chasm, the square partly filled with devout peasants in holiday attire for the church fête, whatever it was. Part of the procession had passed beyond the gloom of the vast aisles into the frank openness of daylight. Between the walls of the small houses at either hand a long line of figures was marching with many silken banners. There seemed to be an interminable line of young girls — first communicants, I fancied,— in all the purity of their white veils and gowns against the somber dull grays of the church. This mass of pure white was of dazzling, startling effect, something like a great bed of white roses.

Then came a phalanx of nuns clad in brown — I know not what their order was — their wide white cowls or coifs

Old Square and Church: Oudenaarde

Old Square and Church: Oudenaarde

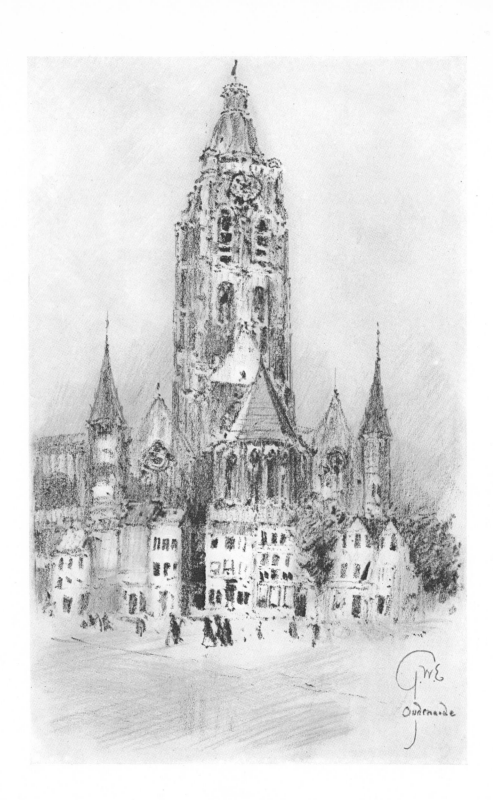

Oudenarde

serving only to accentuate the pallor of their grave faces, veritable " incarnations of meek renunciation," as some poet has beautifully expressed it.

Then followed a group of seminarians clad in the lace and scarlet of their order, swinging to and fro their brazen censers from which poured fragrant clouds of incense.

All at once a curious murmur came from the multitude, followed by a great rustling, as the whole body of people sank to their knees, and then I saw beyond at a distance across the square, the archbishop's silken canopy, and beneath it a venerable figure with upraised arms, elevating the Host.

Surely a moment of great picturesqueness, even to the non-participant; the bent heads of the multitude; the long lines of kneeling black figures; scarlet and gold and lace of the priests' robes against the black note of the nuns' somber draperies; the white coifs and veils, through which the sweet rapture of young religious awe made even homely features seem beautiful: the gold and scarlet again of the choristers; and finally, that culminating note of splendor beneath the silken canopy of the cardinal archbishop (Cardinal Mercier) enthroned here like some ancient venerated monarch; all this against the neutral gray and black lines of the townspeople; surely this was the psychological moment in which to leave Oudenaarde, that I might retain such a picture in my mind's eye.

Furnes

Furnes

THE old red brick, flat topped, tower of St. Nicholas was the magnet which drew us to this dear sleepy old town, in the southwest corner of the Belgian littoral; and here, lodged in the historic hostel of the " Nobèle Rose " we spent some golden days. The name of the town is variously pronounced by the people Foorn, Fern, and even Fearn. I doubt if many travelers in the Netherlands ever heard of it. Yet the town is one of great antiquity and renown, its origin lost in the dimness of the ages.

According to the chronicles in the great Library at Bruges, as early as A. D. 800 it was the theatre of invasions and massacres by the Normans. That learned student of Flemish history, M. Leopold Plettinck, has made exhaustive researches among the archives in both Brussels and Bruges, and while he has been unable to trace its beginnings he has collected and assorted an immense amount of detailed matter referring to Baudoin (or Baldwin) Bras de Fer, who seems to have been very active in harassing the people who had the misfortune to come under his hand.

171

VANISHED TOWERS OF FLANDERS

The War of the "Deux Roses" was fought outside the walls here, likewise the Battle of the Spurs took place on the plains between Furnes and Ypres. Following the long undulations of the dunes from Dunkerque, overgrown here and there with a rank coarse grass sown by the authorities to protect them from the wind and the encroachments of the ever menacing sea, dune succeeds dune, forming a landscape of most unique character. Passing the small hamlet of Zuitcote, marked by the sunken tower of its small church, which now serves as a sort of semaphore for the fishing boats off the coast, one reached the canal which crosses the plain picturesquely. This led one along the path to the quaint old town of Furnes, showing against the heavy dark green of the old trees, its dull red and pink roofs with the bulk of the tower forming a picture of great attractiveness.

The town before the war had about six thousand population which seemed quite lost in the long lines of silent grass grown streets, and the immense Grand' Place, around which were ranged large dark stone Flemish houses of somewhat forbidding exteriors. All the activity of the town, however, was here in this large square, for the lower floors had been turned into shops, and also here was the hotel, before which a temporary moving picture theatre had been put up.

These are very popular in Flanders, and are called

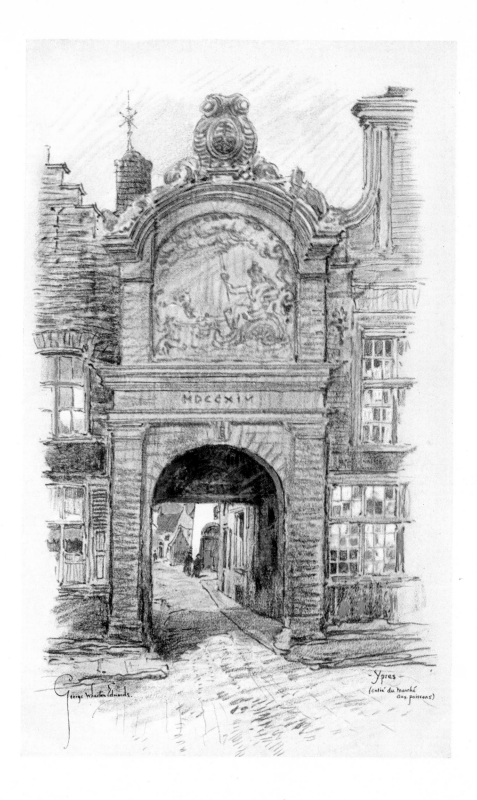

George Wharton Edwards.

Ypres
(entré du marché
aux poissons)

"Cinema-Américain." The portable theatres are invariably wooden and are carried "knocked down" in large wagons drawn by hollowbacked, thick-legged Flemish horses. As a rule they have steam organs to furnish the "music" and the blare of these can be heard for miles across the level plains.

The pictures shown are usually of the lurid sort to suit the peasants, and the profits must be considerable, as the charge is ten and twenty-five cents for admission. On this square is the Hôtel de Ville, the Palace of Justice, and Conciergerie. This latter is a sort of square "donjon" of great antiquity, crenelated, with towers at each corner and the whole construction forming an admirable specimen of Hispano-Flemish architecture.

The angle of the "Place" opposite the pavilion of the officers is occupied by the Hôtel de Ville and the "Palais de Justice," very different in style, for on one side is a massive façade of severe aspect and no particular period, while on the other is a most graceful Flemish Renaissance construction, reminding one of a Rubens opposed, in all its opulence, to a cold classic portrait by Gainsborough.

The Hôtel de Ville, of 1612, exhibits in its "Pignons," its columns and Renaissance motifs, a large high tower of octagonal form surmounted by a small cupola. Its frontage pushes forward a loggia of quite elegant form, with balustrades in the Renaissance style.

Above this grave looking gray building rises the tower of the " Beffroi," part Gothic in style.

All the houses on the " Place " have red tiled roofs, and gables in the Renaissance style very varied in form, and each one with a characteristic window above, framed richly *en coquille*, and decorated with arabesques.

Behind these houses is what remains of the ancient Church of St. Walburga, half buried in the thick verdure of the garden. After considerable difficulty we gained admittance to the ruin, because it is not considered safe to walk beneath its walls. Even in its ruin it was most imposing and majestic. We would have tarried here, but the *custode* was very nervous and hurried us through the thickets of bushes growing up between the stones of the pavement, and fairly pushed us out again into the small parkway, accepting the very generous fee which I gave him with what I should call surliness. But we ignored this completely, after the manner of old travelers, which we had been advised to adopt.

At one side were stored some rather dilapidated and dirty wax figures which reclined in various postures, somewhat too lifelike in the gloom of the chamber, and entirely ludicrous, so much so that it was with much difficulty that we controlled our smiles. The roving eye of the surly *custode*, however, warned us against levity of any sort. These wax figures, he explained, gruffly

enough, were those of the most sacred religious person-
ages, and the attendant saints and martyrs, used in the
great procession and ceremony of the " Sodalité," which
is a sort of Passion Play, shown during the last Sunday
in July of each year in the streets of the town.* The
story relates an adventure of a Count of Flanders, who
brought to Furnes, during the first years of the Holy Cru-
sades, a fragment of the True Cross. Assailed by a tem-
pest in the Channel off the coast, he vowed the precious
object to the first church he came to, if his prayers for
succor were answered. " Immediately the storm abated,
and the Count, bearing the fragment of the Cross aloft,
was miraculously transported over the waves to dry
land."

This land proved to be the sand dunes of Flanders,
and the church tower was that of St. Walburga. After
a conference with his followers, who also were saved, he
founded the solemn annual procession in honor of the
True Cross, in which was also introduced the represen-
tation of the " Mysteries of the Passion." *

This procession was suppressed during the religious
troubles of the Reform, but afterwards was revived by
the church authorities, and now all of the episodes of the
life of Christ pass yearly through the great Grand' Place
— the stable in Bethlehem; the flight into Egypt; down

* This passion play is described in detail in " Some Old Flemish Towns."
(Same author. Moffat, Yard & Co., New York, 1911.)

to the grand drama of the Calvary and the Resurrection, all are shown and witnessed with great reverence by the crowds of devout peasants from the surrounding country. And these pathetic waxen figures were those of Prophets, Apostles, Jews, Angels, Cavaliers and Roman Soldiers, lying all about the dim dusty chamber in disorder. Afterwards, from the window of the quaint Hôtel of the "Nobèle Rose," we saw this procession passing through the crowded streets of Furnes, and almost held our breaths with awe at the long line of black cloaked, hooded penitents, bare-footed, the faces covered so that one could hardly tell whether they were men or women, save for the occasional delicate small white foot thrust forward beneath the black shapeless gown.

And finally *One Figure*, likewise black gowned and with concealed face, staggering along painfully — feebly — and bearing a heavy wooden cross, the end of which dragged along on the stones of the street.*

Outside of this, the Grand' Place, and the old red brick tower of St. Nicholas, so scorched by the sun and beaten by the elements, and the rows of quaint gabled houses beneath, Furnes has little to offer to the seeker after antiquity. The bells in the tower are of sweet tone, but the chimes which hung there were silent, and no amount of persuasion could induce the *custode* to admit me to the

* See "Some Old Flemish Towns."

176

bell chamber. Madame at the " Nobèle Rose " had assured me that I could go up there into the tower whenever I wished, but somehow that pleasure was deferred, until finally we were forced to give it up. Of course Madame *did* rob me; when the bill was presented, it proved to be fifty per cent. more than the price agreed upon, but she argued that we had " used " the window in our apartment overlooking the procession, so we must pay for that privilege. The point was so novel that I was staggered for a suitable reply to it,— the crucial moment passed,— I was lost. I paid!

The Artists of Malines

The Artists of Malines

IT may not be out of place to add here some account of the artists * who dwelt in and made Malines famous in the early days. Primitively the painters formed part of the Society of Furniture Makers, while sculptors affiliated with the Masons' Gild. These at length formed between them a sort of federation as they grew in number and power. Finally, in 1543, they formed the Gild of Saint Luke. In 1560 they numbered fifty-one free masters, who gave instruction to a great number of apprentices. They admitted the gold beaters to membership in 1618, and the following year the organization had increased to ninety-six members.

Working in alabaster was, during this epoch, a specialty with the sculptors of Malines, which soon resulted in a monopoly with them, for they made a law that no master workman could receive or employ more than one apprentice every four years. The workers in gold covered the

* The list is drawn in part from the " Histoire de la Peinture et de la Sculpture à Malines," par Emmanuel Neefs — Gand, Van der Heeghen, 1876, translated from the manuscripts composed in Latin by the painter Egide Joseph Smeyers, Malines, 1774.

statues with heavy ornaments of gold, it being forbidden to market statuary not so gilded. The Gild of Saint Luke chafed under this ruling of the Gild Master, and surreptitiously made and delivered some statuary and paintings without any gilding whatever.

Charges being brought against the offenders, they were fined twenty-five florins, and a law was passed authorized by the magistrate, permitting domiciliary visits upon certain days known only to the officers, to the houses of suspected men engaged in art work. Of course reputable workmen were free from suspicion, it being only those mediocre craftsmen and irregular apprentices who would engage in such traffic.

It was not until 1772 that any sculptor was permitted to paint or gild for profit, nor was any painter allowed to model. The profession of an artist was regarded as less than an industry, being a sort of hand to mouth existence in which the unfortunate was glad to accept whatever work the artisan could give him. In 1783 the Gild had dwindled to twelve members, who finally were absorbed by the Academy of Design, established by Maria Theresa in 1773. Thus perished the Gild of Painters and Sculptors of Malines.

The following is a list of the principal artists and engravers, chronologically arranged, who made Malines famous:

Jean Van Battele, one of the promoters of the Gild of Saint Luke of Malines, was a successful workman in 1403. He was said to be more of a painter-glazer than a painter of pictures, but there is sufficient evidence that he practised both genres.

Gauthier Van Battele, son of the above, was admitted to the Gild in 1426, and figured in the artistic annals of the town in 1474–75.

Baudoin Van Battele, alias Vander Wyck, believed to be " petitfils " of Gauthier, is mentioned in the chronicles of 1495. He painted many mural pictures for the " Beyaerd "; the fresco of the Judgment Day in the great hall of the " Vierschaer " is his greatest work. He died about 1508.

He had one son, Jean, who executed a triptych in the Hôtel de Ville of Malines in 1535, and illuminated a manuscript register on vellum relating to the " *Toison d'Or.*" This book was presented to Charles-Quint, and so pleased him that he ordered a duplicate which cost the artist three years of hard work to complete. He died in July, 1557, highly honored.

Daniel Van Yleghem was the chief workman upon the Holy tabernacle of the chief altar of St. Rombauld. An engraver of great merit; he died in 1451 (?).

Jean Van Orshagen occupied the position of Royal Mint Engraver of Malines, 1464–65. The following

year he was discovered passing false money at Louvain. Imprisoned, he died of the pestilence in 1471.

Guillaume Trabukier excelled in the art of a designer-engraver (ciseleur) in gold. For the town he made many beautiful pieces of work, notably the silver statue of St. Rombauld which decorated the high altar of the Cathedral. He died in 1482.

Zacherie Van Steynemolen, born about 1434, was an excellent engraver of dies. During more than forty years (1465–1507) he made the seals of the town corporations. Notably he engraved for the Emperor Frederic IV the two great seals which are now in the museum. He died in 1507.

Michael or Michel Coxie, le vieux, was a greatly esteemed painter who worked under the direction of Raphaël. His real name was Van Coxciën, or Coxcyën, but he changed its form to Coxie.

His son, Michel Coxie le Jeune, surnamed the Flemish Raphaël, was born in 1499, and first studied under his father. He was shortly placed with Bernard Van Orley, who sent him to Rome, where he might study the work of Raphaël Sanzio. His work was of very unequal merit, although he painted hundreds of compositions in triptych form for the churches. Towards the end of his life he was commissioned to paint a decoration for the Hôtel de Ville of Antwerp. He fell from the scaffolding during

his work, receiving such injuries that he was incapacitated. Removed to his home in Malines, he died after some years of suffering, aged 93 years!

His second son, Raphaël Coxie, born in 1540, was a painter of great merit, whose paintings were ordered for the Royal Spanish Cabinet. He lived at Antwerp, Ghent, and Brussels respectively, and died, full of honors, in 1616.

Michael, or Michel, Coxie, the third of the name, was received in the Gild of Painters the 28th day of September, 1598. He is the author of the triptych over the altar of the "Jardiniers" of Notre-Dame au dela de la Dyle. He died in 1618.

Michel Coxie, the Fourth, son of the above, born September, 1604, was elected to the Gild in 1623. He became Court Painter to the King.

Jean Coxie, son of Michel (above) excelled as a painter of landscape. He it was who decorated the two great salons of the "Parc" Abbey. The subjects were drawn from the life of Saint Norbert.

His son, Jean-Michel, though a member of the Gild of Malines, passed almost his whole life in Amsterdam, Dusseldorf, and Berlin. In the latter town he enjoyed the favor and patronage of Frederick I. He died in Milan in 1720.

Jean de Gruyter, gold worker and engraver, came in

1504 to Malines, where he enjoyed a certain renown. After his death in 1518, his sons Jean and Pierre continued the work which he began. Jean made seals of great beauty of detail, but Pierre was condemned to banishment in 1536 and confiscation of all his goods and chattels, for counterfeiting the state coinage.

Jean Hoogenbergh, born about 1500, was a successful painter of miniatures; he lived about fifty years.

Jean Van Ophem was appointed Civic Engraver of Seals and Gold Worker. He died in 1553.

François Verbeek became master workman in 1531, and finally *doyen* of the craft. He abandoned oil painting for distemper, in which medium he excelled, producing masterpieces depicting the most fantastic subjects. He died in July, 1570.

Hans Verbeek, or Hans de Malines, believed to be the son of François. He was Court Painter to Albert and Isabella. He died sometime after 1619.

Grégoire Berincx, born in 1526, visited Italy and there made paintings in distemper of the ruins and ancient constructions. Returning to his native town in 1555 he was at once made a Gild Member of the Corporation of Painters. He died in 1573.

His youngest son, Grégoire, became *doyen*, and of him the following story is told: The great Van Dyck visited him unexpectedly one day, and demanded that he

186

make a sketch of him (Van Dyck) at once, in his presence. Berincx accordingly painted in monotone the sketch in full length, adding the details in carnation, and so charmed was Van Dyck, that he assured him that he would adopt the system in his own work, " if he would permit." He died full of honors the 14th of October, 1669.

Jacques de Poindre, born in 1527, acquired a brilliant reputation as a portrait painter. He afterwards established himself under royal patronage in Denmark where he died in 1570.

Corneille Ingelrams, a painter in distemper, was born in 1527. He practised his art successfully in Malines and died in 1580.

His son, André, was admitted to the Painters' Gild in May, 1571, and died in 1595.

Marc Willems, born about 1527, was a pupil of Michel Coxie (le vieux), was considered a great painter in his time. He made many designs for the decorators, and admirable cartoons for tapestry makers. He died in 1561.

Jean Carpreau was commissioned in 1554 to take charge of the restorations of the " chasse " of the patron saint of the town. Such was his success that he was appointed Official Seal Cutter and Engraver, a position of great importance in those days. At the Hôtel de Ville was preserved and shown a remarkable die in silver from his hand, for the Seal of the Municipality of Malines.

Jean or Hans Bol, born December, 1534, was the pupil of his uncles Jacques and Jean the Elder, but after two years of apprenticeship he went to Germany for a time. Returning to Malines, he devoted himself to the painting of landscapes with great success. Likewise he sometimes engraved plates on copper. His productions are many. He died at Amsterdam in 1593.

Lambert de Vos, admitted to the Gild of Saint Luke in 1563, was engaged in the service of Charles Kimy, Imperial Ambassador to Constantinople. He painted oriental subjects in water colors, which were distinguished for richness of color, and accuracy of drawing. Many of these are in the Library of Brême.

Jean Snellinck, born about 1554, was an historical and battle painter. It was he who prepared the designs for the tapestries of Oudenaarde. During his residence in that town he painted the triptych for the church of Notre Dame de Pamele. He died at Antwerp in 1638.

Louis Toeput was born about 1550. He was a landscape painter of renown, but also drew many architectural subjects. In his later period, he devoted himself to Flemish literature with marked success as an authority.

Luc Van Valckenborgh, called "partisan of the Reform," was born in 1566, and in his student days went to Germany, where he practised his art as a portrait painter.

His reputation was made by his portrait of the Archduke Matthias.

He died in 1625, leaving a son Martin, also his pupil, who established himself at Antwerp and later at Frankfort. Martin was an historical and landscape painter, although he painted some good portraits in the manner of his father. He is thought to have died about 1636.

Philip Vinckboons, the elder, was born about 1550, became an associate of the Gild of Painters in 1580, and died 1631. His son Maur, the younger, born 1585, studied painting under his father, finishing under his uncle Pierre Stevens. He died in 1647.

Pierre Stevens, born about 1550, was an historical painter and engraver, as well as a portrait painter. This master latinized his name and signed his works thus — P. Stephani. He died in 1604 at Prague, where he had dwelt since 1590, under the patronage of the Emperor Rudolphe II.

Rombaut Van Avont, incorporated in the Gild of Saint Luke in 1581, was a sculptor and painter as well as an illuminator of manuscripts on vellum. He died in 1619. His son Pierre, born in 1599, was an excellent painter of landscapes, which were distinguished by a most agreeable manner. Admitted as a " franc maitre " at Antwerp, he became one of the burgesses of that town in October, 1631.

Luc Franchoys, the elder, born January, 1574, was ad-

mitted to the Gild in 1599. A painter of remarkable talent, he turned to historical subjects, which he produced with great success. In drawing, too, he was most skillful and correct. He died in 1693 and was buried with honors in the church of St. Jean.

His son Pierre, born in 1606, became pupil of Gerard Seghers of Antwerp, where he resided for some time. Afterward he lived in Paris, where his works were eagerly sought and appreciated. He never married, but always surrounded himself with young pupils to the time of his death in 1654.

His younger brother, Luc, was born 1616. He remained with his father, working in his studio until he was admitted to the Gild, when he went to Paris, where he painted portraits of members of the Court, enjoying considerable renown and favor. He returned finally to Malines, where he died in April, 1681.

Frans Hals (The Great), was born either here in Malines, or at Antwerp, in 1584. Accounts differ. His parents were citizens of Malines, at any rate. He had the honor and glory of introducing into Holland the " procede magistral " of Rubens and his school. His works are too well known to need description here. He established himself at Haarlem, where he died in great poverty in 1666. Not even his burial place is now known.

Jean le Saive of Namur, son of Le Saive the Elder, was

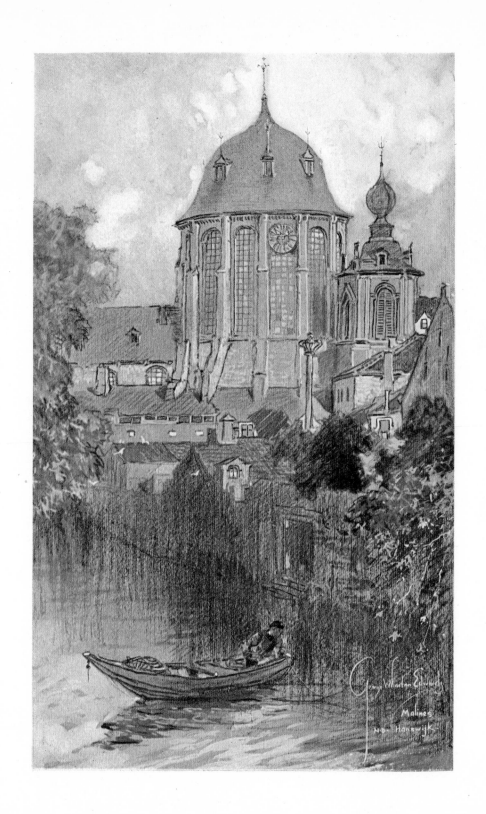

born in the commencement of the seventeenth century. He painted animals, landscapes, and historical subjects. In the latter genre he is inferior to his father; his color is drier, and his drawing less correct. The date of his death is not recorded.

George Biset, painter-decorator, entered the studio of Michel Coxie (Third) in 1615. He lived throughout his life at Malines, and died 1671.

His son, Charles Emmanuel, born 1633, was an excellent portrait painter, enjoying much appreciation at the Court of France. He became Burgess of Antwerp in 1663, and was elected a Director of the Academy. He died at Breda in 1685.

Martin Verhoeven was elected to the Gild in 1623. He painted flowers and fruit pieces which enjoyed great celebrity.

His brother Jean was known as a portraitist of great ability. In late life he produced some good sculptures.

David Herregouts, born 1603, was elected to the Gild in 1624. Examples of his work are rare. He died at Ruremonde. His son Henri was a pupil of his father. David went to Italy, residing at Rome. After traveling in Germany he returned to Malines, and died at Antwerp at an advanced age.

Jacques de (or Van) Hornes, painter in distemper, was a pupil of Grégoire Berincx (Second) and executed much

work in " ciselé " under the direction of Fayd'herbe. He died in 1674.

Jean Philippe Van Thieleu, born 1618, was an eminent flower and still-life painter, under the guidance of Daniel Zeghers. He was patronized by the King of Spain, and died in 1674.

Ferdinand Elle, born 1631, according to some; in 1612, say other accounts, painter of portraits, went to Paris, where he remained until his death in 1660 (?).

Gilles (or Egide) Smeyers, historical painter, was born in 1635, and studied under his father Nicholas, later under Jean Verhoeven. In friendship for his companion and master Luc Franchoys the younger, he finished many of the latter's incompleted works after his death.

His son Jacques, born 1657, was admitted to the Gild in 1688, and died in 1732.

Egide Joseph, natural son of Jacques, born 1694, was an historical painter, as well as a poet. He lived at Dusseldorf for three years. Obliged to support his sick parents, he did a great deal of work. Smeyers had a profound knowledge of the Latin tongue, which he wrote with great fluency and ease, in both poetry and prose. He possessed, too, a working knowledge of French, German, and Italian. His historical works are many. At length, sick and helpless, he was admitted to the hospital of Notre

Dame, where he died in 1771. He painted the large portrait of Cardinal Thomas Philippe d'Alsace, Archbishop of Malines.

Daniel Janssens, born in 1636, was a painter-decorator of the first order. He adopted the manner of Jacques de Hornes of whom he was the favorite pupil. After having resided in Antwerp for some years he returned to Malines, where he died in 1682. He it was who designed and constructed the immense triumphal arch for the Jubilee of 1680. This arch is preserved in the Town Hall, and serves to decorate the façade of the " Halles " on the occasion of the Grandes Fêtes.

Sebastian Van Aken, born 1648, was pupil of Luc Franchoys the Younger. Later he entered the studio of Charles Maratti in Rome. After painting in Spain and Portugal he returned to Malines, where he died in 1722.

August Casimir Redel, born 1640. This painter of merit became insane from excesses and died in 1687. He was also the author of a life of St. Rombaut (Rombold) and wrote much in verse. He composed an ode on the occasion of the Jubilee of Malines in 1680.

Jacques la Pla, pupil of Jean le Saive, a master painter of Malines in 1673, died in 1678.

Jean Barthelemy Joffroy, born 1669, was historian, painter, and engraver. He died 1740.

VANISHED TOWERS OF FLANDERS

Jean Joseph Van Campenhout, designer and engraver. He was designer of the great book of the " Cavalcade of Malines " in 1775.

Antoine Opdebeek, born 1709, author of many paintings of merit, was an untaught genius. Employed in the hospital of St. Hedwige in Malines, he taught himself the art, with success, but never reached the height which would have been his had he had instruction in his youth. He died 1759.

Pierre Antoine Verhulst, born 1751, painter of marines and landscape, which he executed with great delicacy and charm, died 1809.

Matthieu Joseph Charles Hunin, born 1770, was a master engraver, producing many plates after Rubens and other masters. To his talent is also due a great number of original engravings of the Tower of St. Rombold; the interior and exterior of the Cathedral of Antwerp; the Hôtels de Villes of Oudenaarde, Brussels and Louvain, etc., etc. He died in 1851.

His son, Pierre Paul Aloys, born 1808, was a genre painter of great taste and renown. His works in which the painting of silk and satin appeared were in great demand. He was professor of the Malines Academy, and in 1848 Leopold I conferred upon him the decoration of the Order of Leopold. He died February 27th, 1855.

Many of his paintings have been reproduced in engravings.

Jean Ver Vloet, the *doyen* of the artists of Malines, died October 27th, 1869, after a long and successful artistic career. One of the founders of the society " Pour l'Encouragement des Beaux Arts " of Malines, he was indefatigable in all art movements of the town. To him was due the success of the magnificent Cavalcades for which Malines has been famous. For fifty years he was the director of the Academy of Design and Painting of his native town.

This ends the list of famous painters of Malines, and so far as I know it is the first and only one in English. Did space permit I might include the architects who made Flanders famous the world over as the cradle of art and architecture.

A Word About the Belgians

A Word About the Belgians

THE little country called Belgium, it should be remembered, dates only from 1830, when the existing constitution was prepared and adopted for the nine southern provinces of the ancient Netherlands. The sudden and unexpected revolt against the Dutch in that year has been since styled "a misunderstanding" upon the part of the Belgians, and was brought about by the action of the King, William I, of the house of Orange-Nassau, who attempted ostentatiously to change at once the language and religion of his southern subjects. They were both Roman Catholic and conservative to the last degree, attached to traditional rights and forms and fiercely proud of the ancient separate constitutions of the southern provinces, which could be traced back to the charters of the Baldwins and Wenceslas.

Undoubtedly the French Revolution of 1830, which closed the Monarchy of the Bourbons, hastened the crisis. For the Belgians had no liking for the rule of the House of Orange-Nassau against which they had discontentedly struggled for some years more or less openly. But mat-

ters might have gone on thus indefinitely had not the French Revolution furnished ground for hope of support from a people akin in religion and language, as well as race. The smouldering fire of discontent broke into fierce flame on August 25th, 1830, in the city of Brussels, during a performance of the opera " Muette de Portici," when the tenor was singing the inspired words of Massaniello:

> " Plutôt mourir que rester misérable,
> Pour un esclave est-il quelque danger?
> Tombe le joug qui nous accable,
> Et sous nos coups perisse l'étranger.
> Amour sacré de la patrie,
> Rends nous l'audace et la fierté;
> À mon pays je dois la vie,
> Il me devra sa liberté!"

The immense audience, roused to patriotic enthusiasm, took up the words of the song and, rushing from the theatre *en masse*, paraded the streets, attacking the residences of the Dutch ministers, which they sacked and burned.

The few troops in the town were powerless to stem the revolt, which grew until Brussels was entirely in the hands of the revolutionists, who then proceeded to appoint a Council of Government, which prepared the now celebrated Document of Separation.

William sent his son, the Prince of Orange, to treat

with the Council, instead of sending a force of soldiers with which the revolt might have been terminated easily, it is claimed. The Prince entered Brussels accompanied only by a half dozen officers as escort. After three days' useless parley, he returned to King William with the " Document of Separation."

The reply of the King to this message was made to the Dutch Chambers ten days later. Denouncing the revolt, he declared that he would never yield to " passion and violence." Orders were then issued to Dutch troops under Prince Frederick of Holland to proceed to Brussels and retake the city. The attack was made upon the four gates of the walled city on September 23rd. The Belgians prepared a trap, cunningly allowing the Dutch soldiers to enter two of the gates and retreating towards the Royal Park facing the Palace. Here they rallied and attacked the troops of William from all sides at once. Joined by a strong body of men from Liège they fought for three days with such ferocity that Prince Frederick was beaten back again and again, until he was forced to retreat at midnight of the third day.

In the battle six hundred Belgian citizens were slain, and to these men, regarded now as the martyrs of the Revolution, a great monument has been erected in the Place des Martyrs, near the trench in which they were buried.

A provisional government was now formed which is-

sued the following notice: "The Belgian provinces, detached by force from Holland, shall form an independent state." Measures were taken to rid the country of the Dutch, who were expelled forcibly across the border.

Envoys to Paris and London presented documents to secure sympathy for the new government, while the fight for independence was still going on fiercely. Waelhern and Berchem, besieged by the Belgian volunteers, soon fell, and the city of Antwerp was occupied by them before the end of October.

Then the Conference of the Five Powers, sitting in London, interposed to force an armistice in order to determinate some understanding and arrangement between the Dutch and the Belgians, since it had become evident that the Netherlands kingdom of 1815 had practically come to an end. By the treaty of London in 1814, and that of Vienna in 1815, Belgium, after a short interregnum of Austrian rule, was incorporated with Holland into the Kingdom of the Netherlands.

In the space of a month then the Belgian patriots had accomplished their task, and on November 18th the National Assembly, convoked, declared as its first act the independence of the Belgians.

It was now necessary to find a head upon which to place the crown. The first choice of the provisional government was the Duc de Nemours, the son of Louis

Philippe, but objection was made to him on the ground that his selection would add too much, perhaps, to the power of France, so his candidature was withdrawn.

Choice was fixed finally upon Prince Leopold of Saxe-Coburg, who had but recently declined the throne of Greece by advice of the European diplomats. A resident of England, this Prince, who had espoused Princess Charlotte, the daughter of George IV, was well known as a most clear headed diplomat, a reputation he enjoyed during his whole career.

In his acceptance he said: "Human destiny does not offer a nobler or more useful task than that of being called to found the independence of a nation, and to consolidate its liberties."

The people hailed and received him with great enthusiasm, and on July 21st he was crowned King of the Belgians, with most impressive ceremonies, at Brussels. The Dutch, however, viewed all this with much concern, and at once began hostilities, thinking that the powers would sustain them rather than permit France to occupy Belgium. At once Dutch troops were massed for attack on both Brussels and Louvain. Outnumbered by the Dutch, the badly organized national forces of Belgium met disaster at Hasselt, and, realizing his peril, Leopold besought the French, who were at the frontier, to come to his assistance. Simultaneously with the assault on Lou-

vain, therefore, the French troops arrived at Brussels. Great Britain now entered the fray, threatening to send a fleet of warships to occupy the Scheldt unless King William recalled his army from Belgium. This settled the matter, and the Dutch withdrew. The French likewise returned to their own territory. Jealousy, however, was manifested by Austria, Prussia and Russia toward the new kingdom, and their refusal to receive Leopold's ambassadors was calculated to encourage hope in Holland that the reign of the new monarch was to be limited.

New troubles began for the Belgians, in the presentation of the London Protocol of October 15, 1831, in consequence of a demand that the greater part of Limbourg and Luxembourg be ceded. Not only the Belgians but the Dutch opposed this demand, as well as the conditions of the protocol. And at once King William prepared for armed resistance. Leopold immediately after obtaining votes for the raising of the sum of three millions sterling for war purposes, increased the army to one hundred thousand men.

Now ensued a most critical period for the little kingdom, but both France and England held their shields over it, while Leopold's marriage to the Princess Louise, eldest daughter of King Louis Philippe, gained for it still greater strength in its relations with France.

King William, however, refused stubbornly to recog-

nise the protocol, and retained possession of Antwerp, which he held with a garrison of five thousand soldiers. Antwerp Citadel being the pride of the kingdom, the Belgians, restive under the control of the powers, demanded that both England and France help them at once to recover it, alleging that in case this help was refused, they, with their hundred thousand men, were ready to capture it themselves. So in the month of November the French troops, under Maréchal Gérard, laid siege to the Antwerp stronghold, held by General Chassé, who after three weeks' siege capitulated, and the Dutch, rather than have their warships captured, burnt and sank them in the Scheldt.

With the surrender of Antwerp, the French withdrew their army, but the Dutch sullenly refused to recognise the victory until the year 1839, when they withdrew from and dismantled the forts on the Scheldt facing Antwerp.

Naturally the support of the French and English brought about a deep and lasting feeling of gratitude on the part of the Belgians. Louis Philippe said, " Belgium owes her independence and the recovery of her territory to the union of France and England in her cause."

Her independence thus gained and recognised, Belgium turned her attention to the development of the country and its rich natural resources. The Manufactures flourished, her mines of coal and iron became fa-

mous throughout the world, and she trod the peaceful path of strict neutrality among the great nations. Passing over the all familiar history of Waterloo, one may quote the saying of M. Northomb: "The Battle of Waterloo opened a new era for Europe, the era of representative government." And this new era was enjoyed by Belgium until the Franco-Prussian War confronted the little country with a fresh crisis, and one fraught with danger. Although her absolute neutrality had been earnestly proclaimed and presented to the powers, it was feared that she might be invaded and be unable to maintain her integrity by her military force.

Leopold promptly mobilized the army and massed it upon the frontier. During and after the battle of Sedan, a large number of both French and German soldiers crossed the border and were interned until the close of the war. . . . Once more peace descended upon the Belgians, for a fresh treaty prepared by England and signed by both France and Prussia engaged the British Government to declare war upon the power violating its provisions.

After his acceptance of the Crown of Belgium, the Constitution declared the monarchy hereditary in the male line of the family of Prince Leopold of Saxe-Coburg, which consisted of two sons and one daughter. The elder of the sons was born in 1835, and succeeded his father

A WORD ABOUT THE BELGIANS

as Leopold II, in 1865. The Austrian Archduchess Marie
Henriette became his wife in 1853, and their descendants
were one son and three daughters, none of whom is now
living. The Salic Law prevailing in Belgium, the his-
tory of the female descendants is not of political impor-
tance. The only son of Leopold II dying in 1869, the
succession passed to the brother of the King, the Count
of Flanders, who married Mary, Princess of Hohenzol-
lern, a sister of the King of Roumania.

The death of their son Prince Baldwin in 1891 was held
to be a national calamity. This left the nephew of Leo-
pold II, Prince Albert (the present King of Belgium), the
heir presumptive to the throne. He married in 1900 the
Princess Elizabeth of Bavaria; to them have been born
three children, two boys and a girl. Both the King and
Queen, the objects of intense devotion on the part of the
Belgians, are very simple and democratic in their bearing
toward the people. The Queen is a very beautiful
woman, and a most devoted wife and mother. . . .
Since the seat of government has been removed to Havre,
the Queen divides her time between the little hamlet of
La Panne, headquarters of the Belgian army, near the
town of Furnes on the dunes of the north sea, and Lon-
don, where the children are being cared for and educated.
. . . May not one hope that brighter days are in store for
this devoted and heroic King and Queen, for the once

smiling and fertile land, and for the kindly, gentle, and law abiding Belgian people? *

* The author refers the reader to " The Constitution of Belgium," J. M. Vincent, Phila., 1898; " Belgium and the Belgians," C. Scudamore, London, 1904; " History of Belgium," D. C. Boulger, London, 1900; " The Story of Belgium," C. Smythe, London, 1902.

THE END

INDEX

INDEX

INDEX

INDEX